IMAGES
of America

FLORIDA
LIGHTHOUSES

IMAGES
of America

FLORIDA
LIGHTHOUSES

John Hairr

ARCADIA
PUBLISHING

Published by Arcadia Publishing
Charleston, South Carolina

Printed in the United States of America

Library of Congress Catalog Card Number: 99-067141

For all general information contact Arcadia Publishing at:
Telephone 843-853-2070
Fax 843-853-0044
E-mail sales@arcadiapublishing.com
For customer service and orders:
Toll-Free 1-888-313-2665

Visit us on the Internet at www.arcadiapublishing.com

CONTENTS

ACKNOWLEDGMENTS

Several individuals, in numerous libraries, museums, and institutions, helped to make this project possible. Patricia Roberson of the Florida State Archives provided much needed assistance with reproducing images from their extensive photographic collections. Several staff members at the Library of Congress and National Archives helped locate images in their vast collections, many of which are published here for the first time.

Scott Price and the staff at the Historian's Office of the U.S. Coast Guard provided valuable assistance in locating elusive images of lighthouses, as well as little-known facts about some of these structures.

Rob Shanks of Biscayne National Park was extremely helpful in tracking down an image of the Boca Chita Tower.

Melanie Brown of the St. Augustine Lighthouse and Museum provided access to that organization's vast resources, which deal with one of the most historic areas of the United States.

Tom Taylor, Lighthouse Historian and president of the Florida Lighthouse Association, provided kind and valuable assistance in locating images of the Ponce de Leon Inlet Lighthouse.

I would also like to express my appreciation to Bernice Shore, who graciously granted permission to use her late husband's photograph of the Cape St. George Lighthouse. Arnold Shore's photo of the "Leaning Tower of Florida" can be seen on page 115.

INTRODUCTION

The Florida peninsula extends south from the mainland of North America, separating the Atlantic Ocean from the Gulf of Mexico. Florida sports the second longest coastline in the United States, trailing only Alaska. Including the bays, islands, and lagoons, Florida has over 8,000 miles of coastline.

Several capes jut out from the Florida peninsula, including Cape Canaveral, Cape Saint George, and Cape San Blas. In addition, there are numerous reefs, rocks, and shoals to snag unwary mariners trying to get around the southern end of the state. It is no wonder that over 2,000 ships have wrecked in the waters off Florida.

As trade grew between American ports on the East Coast with ports along the Gulf of Mexico such as New Orleans, transportation in the seas off Florida increased. It became necessary to erect aids to navigation along the coast. Lighthouses were built on what, at the time, were some of the most desolate regions of the southeastern United States, including sites on lonely islands offshore. As the population of the state grew and commerce increased, lights were needed to show the way into the harbors and inlets.

The lighthouses in the state of Florida come in a variety of styles and sizes. There are large brick structures such as those at St. Augustine, Pensacola, and Ponce de Leon Inlet. There are iron skeleton towers, such as those at Crooked River and Hillsboro Inlet. There are a number of screwpile lighthouses in the waters off the Florida Keys. There are even lights erected on the top of the lightkeeper's dwelling, such as the lighthouse on Gasparilla Island.

This book is a tour of these old lighthouses along the Florida coast from Amelia Island to Pensacola and includes numerous photos that date back to the nineteenth century and several to the early twentieth century.

In this day of Global Positioning Systems and satellite navigation, many lighthouses have become obsolete. Fortunately, several organizations have sprung up to preserve these historic treasures for future generations. If you would like to learn more about these ongoing preservation efforts, contact the Florida Lighthouse Association at 4931 South Peninsula Drive, Ponce Inlet, Florida 32127.

One

AMELIA ISLAND TO
ST. AUGUSTINE

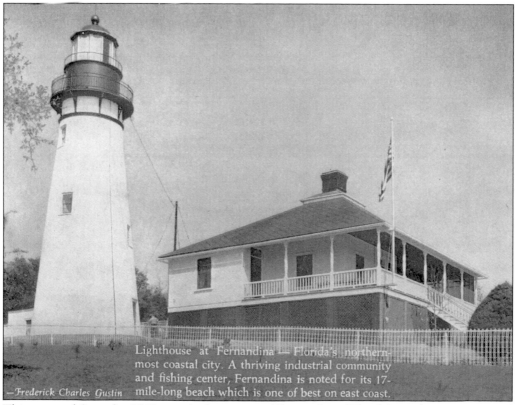

Lighthouse at Fernandina — Florida's northernmost coastal city. A thriving industrial community and fishing center, Fernandina is noted for its 17-mile-long beach which is one of best on east coast.

—*Frederick Charles Gustin*

This postcard from the 1940s extols the virtues of Fernandina, "Florida's northernmost coastal city." (Florida State Archives.)

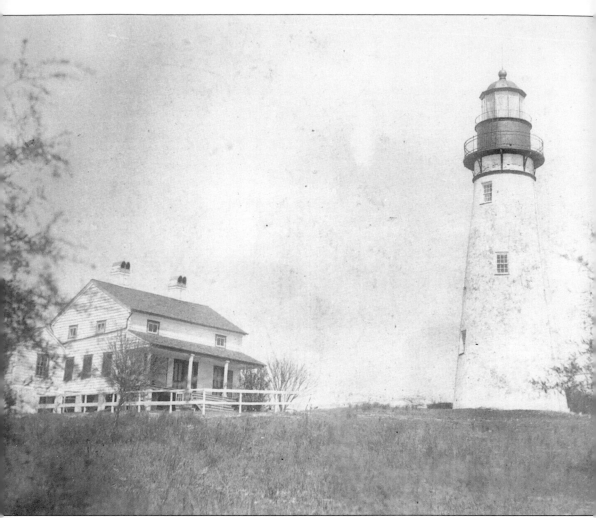

The lighthouse on Amelia Island was completed in 1839. The structure had originally stood across the St. Mary's River on Cumberland Island, Georgia, but as the main channel into St. Mary's River shifted south, it became more practical to have a lighthouse on Amelia Island. This view of the lighthouse and the keeper's quarters was taken shortly after the new cupola was added to the top of the lighthouse in 1881. (National Archives.)

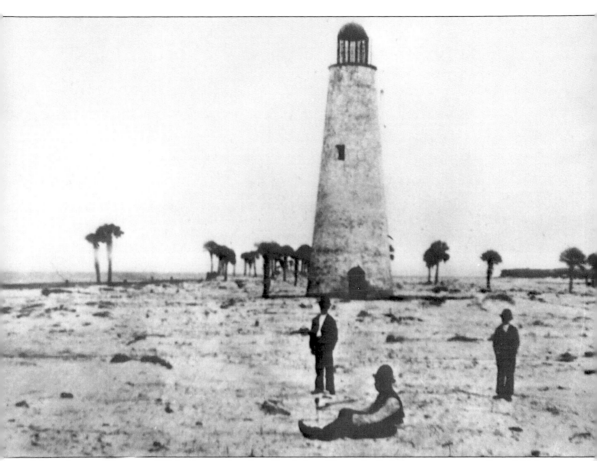

This photo, taken in 1833, shows the first St. Johns River Lighthouse, constructed in 1830. This lighthouse stood on the south side of the mouth of the St. Johns River. Shortly after its construction, the site was threatened by the encroachment of the sea. This old lighthouse was torn down in 1833, its 150,000 bricks were salvaged, and a replacement was built further inland in 1835. The second structure also became threatened by the sea and was thus abandoned for a third structure built even further inland in 1859. (Florida State Archives.)

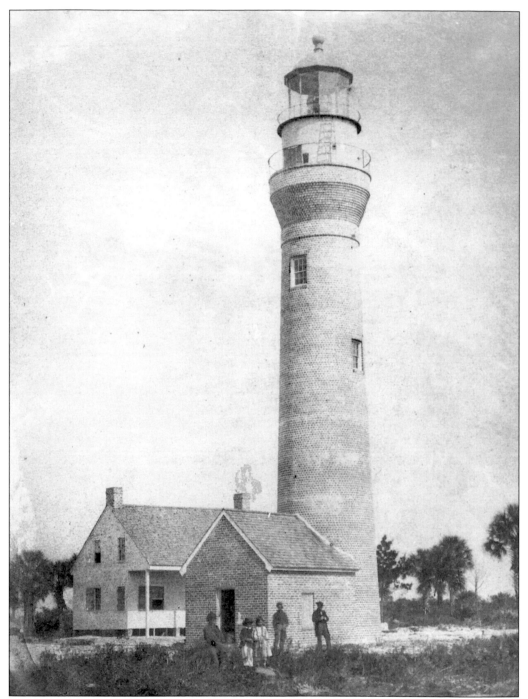

The third St. Johns River Lighthouse was completed in 1859. The brick structure stood 63 feet tall, but throughout its years of service, mariners complained that the lighthouse was inadequate, suggesting that its height be raised. The lighthouse ceased operations in 1930. (National Archives.)

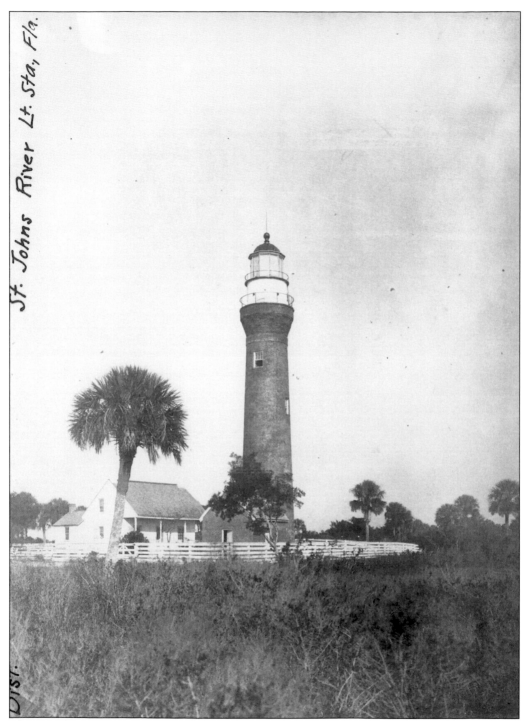

St. Johns River Lt. Sta, Fla.

DIST.

The St. Johns River Lighthouse is shown here in this photo taken *c*. 1895. (National Archives.)

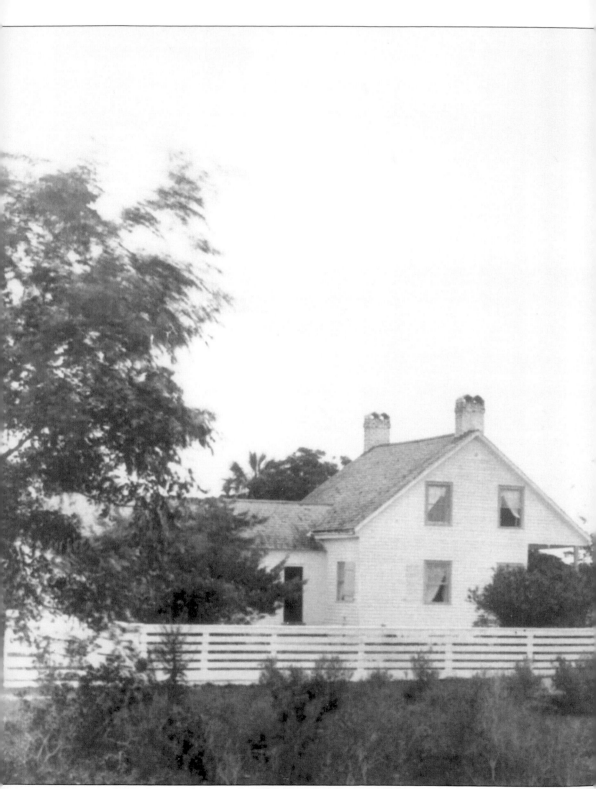

Major Jared Smith took this photo of the St. Johns River Lighthouse and the keeper's quarters

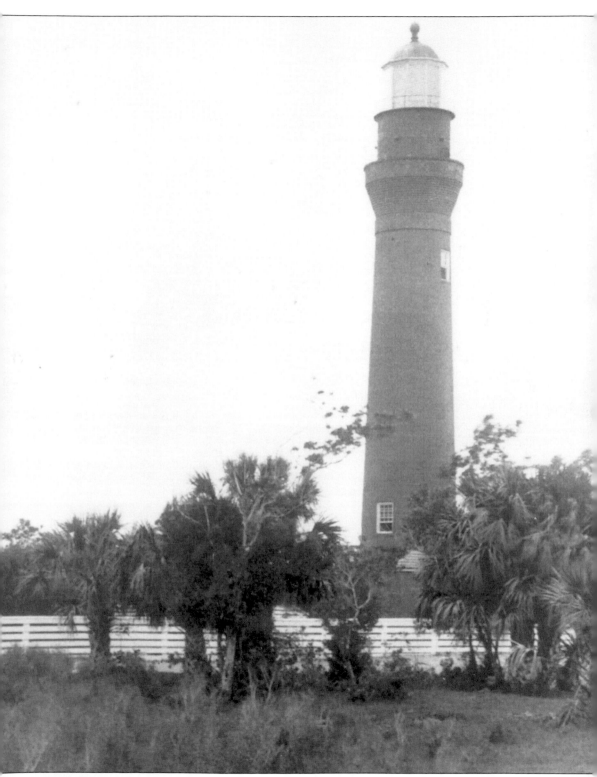

in 1885. (National Archives.)

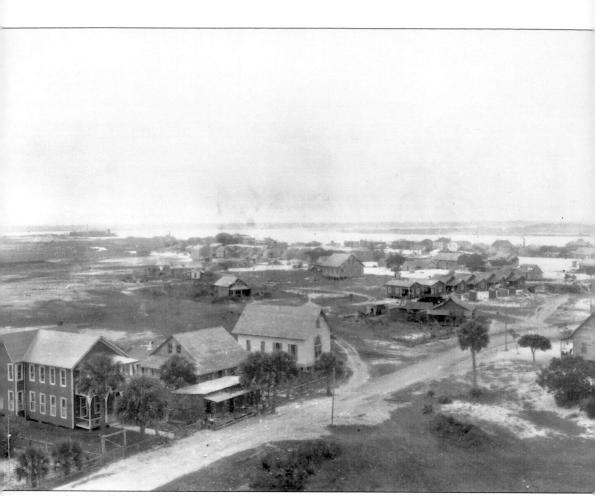

John Small took this photograph of Mayport from atop the St. Johns River Lighthouse in 1922. (Florida State Archives.)

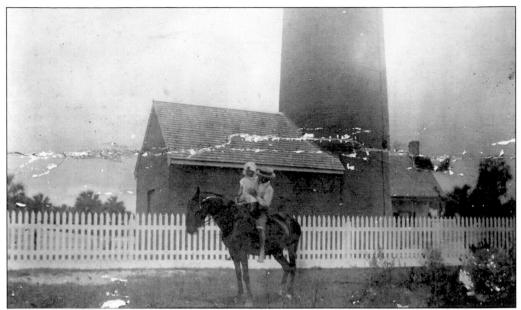

Ed and Althea Estell are sitting on a horse in front of the St. Johns River Lighthouse, c. 1895. (Florida State Archives.)

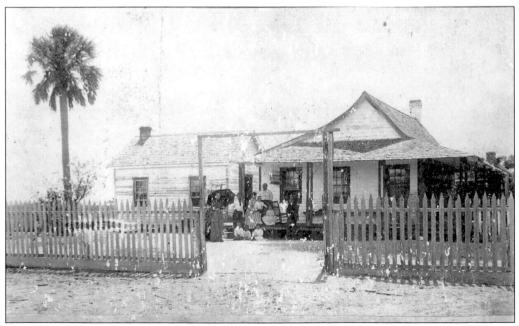

John Daniels, lightkeeper at St. Johns River from 1858 to 1870, is shown here with his family in front of their home at Mayport. (Florida State Archives.)

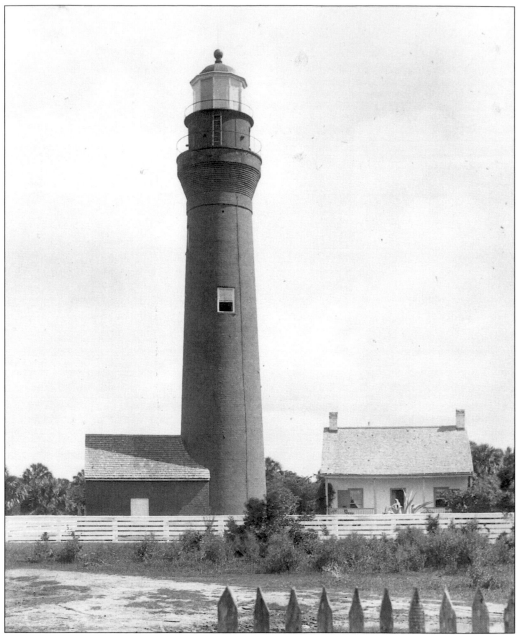

Major Smith captured this view of the St. Johns River Lighthouse in June 1885. (National Archives.)

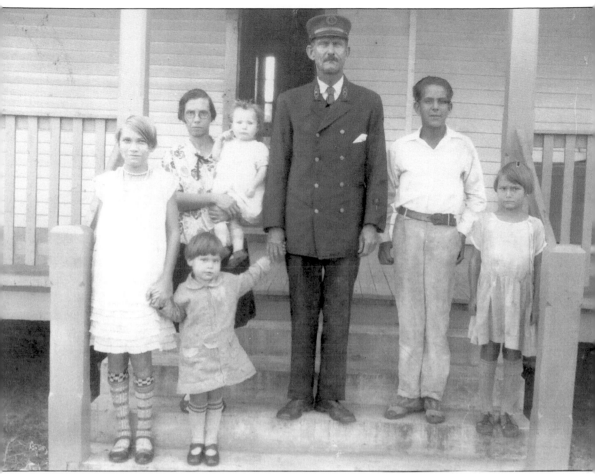

Lightkeeper Charles Sisson poses with his family at the St. Johns River Light Station, *c.* 1926. (Sisson Family Collection, Ponce de Leon Inlet Lighthouse Preservation Association.)

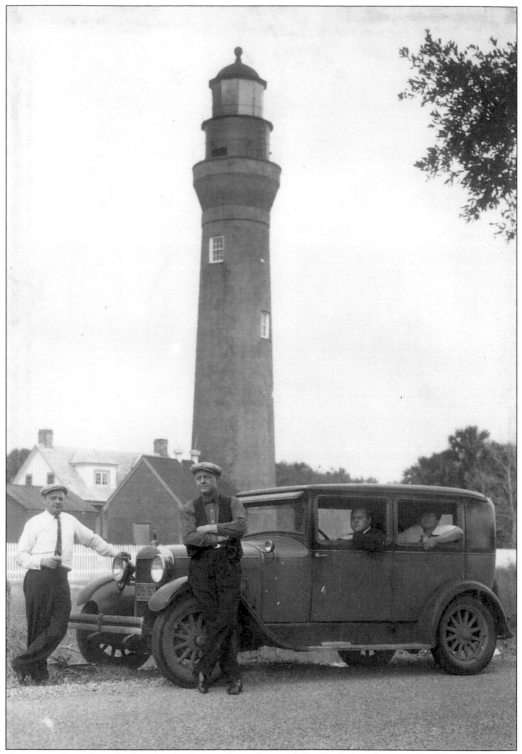

A group of unidentified individuals stands in front of the St. Johns River Lighthouse. (Florida State Archives.)

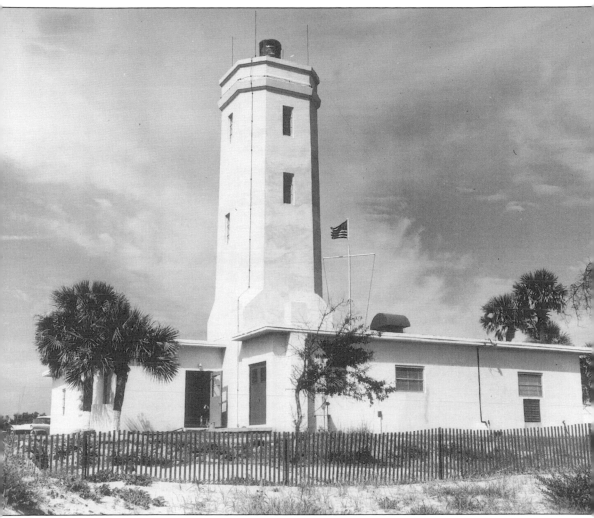

In 1954, a new lighthouse was constructed at the entrance to the St. Johns River. The concrete structure is 83 feet tall. It was manned by Coast Guard personnel until it was automated in 1967. The photo above shows the structure in the summer of 1955. (U.S. Coast Guard photo.)

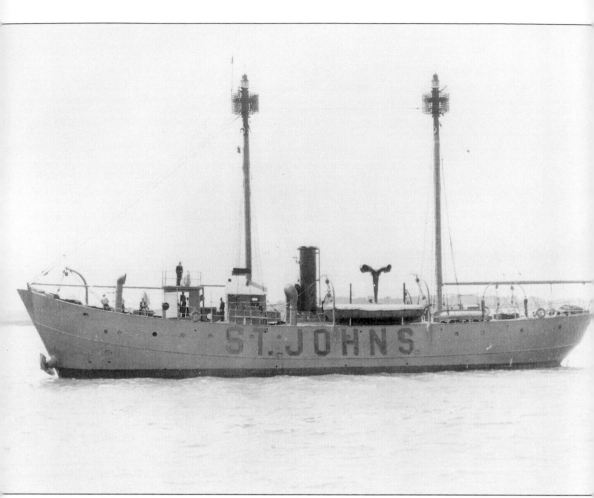

The St. Johns Lightship took up station at the mouth of the St. Johns River in January 1929. Built in 1907, the ship was originally painted yellow but was repainted red in 1943. The lightship ended its service in the Jacksonville area in 1954 when the new St. Johns Lighthouse was put into operation. (U.S. Coast Guard Photo.)

The radiobeacon installation inside the St. Johns Lightship was photographed in July 1930. (U.S. Coast Guard Photo.)

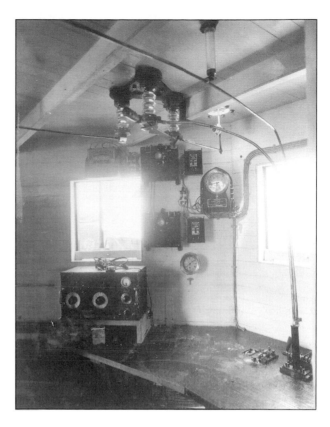

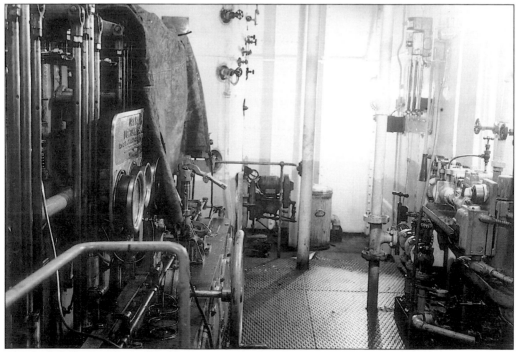

This is the engine room of the St. Johns Lightship. (U.S. Coast Guard Photo.)

This is a view of St. Johns River Light Station. It is located in Mayport, Florida, less than a mile from the mouth of the St. Johns River. The two concrete-block buildings, seen in the foreground, are for the light station attendants and their families. (U.S. Coast Guard photo.)

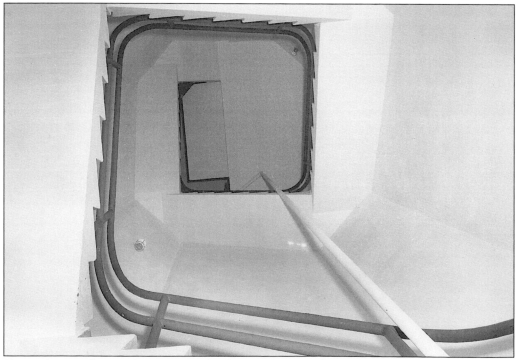

Shown here is the winding staircase leading to the top of St. Johns River Lighthouse. (U.S. Coast Guard photo.)

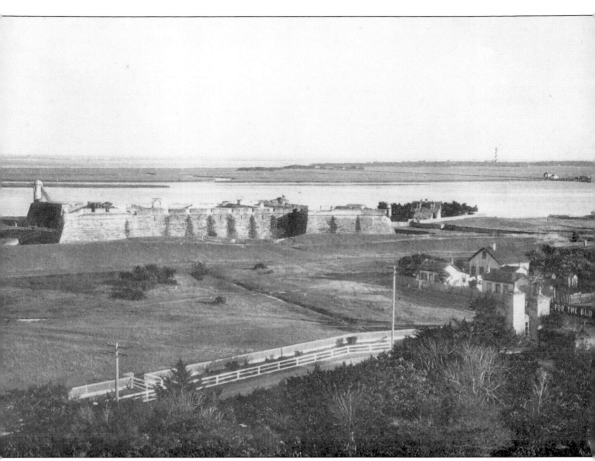

A visitor to St. Augustine's Hotel San Marco captured this image of Fort Marion (Castillo de San Marcos) and St. Augustine Inlet in 1891. The lighthouse on Anastasia Island can be seen in the background. (Florida State Archives.)

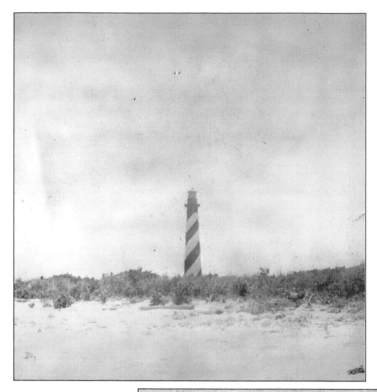

This photo is of the lighthouse on Anastasia Island, taken May 13, 1895. (Florida State Archives.)

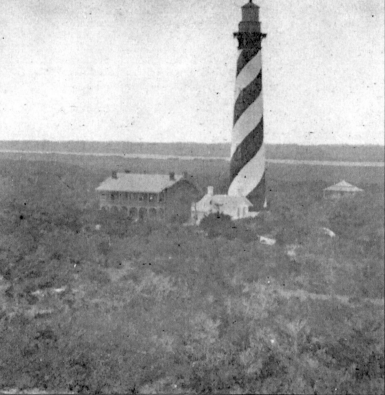

This photo taken in the late 1800s shows the Anastasia Island lighthouse and accompanying buildings. (Florida State Archives.)

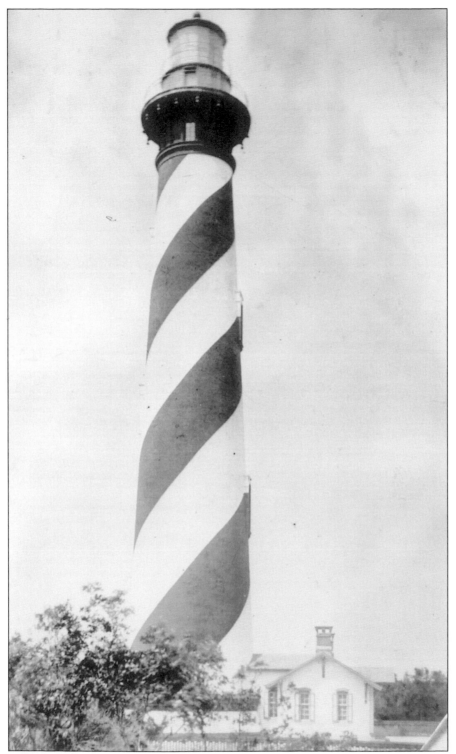

This image is of the St. Augustine Lighthouse and Keeper's Quarters as they appeared in 1885, just eight years after the 165-foot tower was completed. (Florida State Archives.)

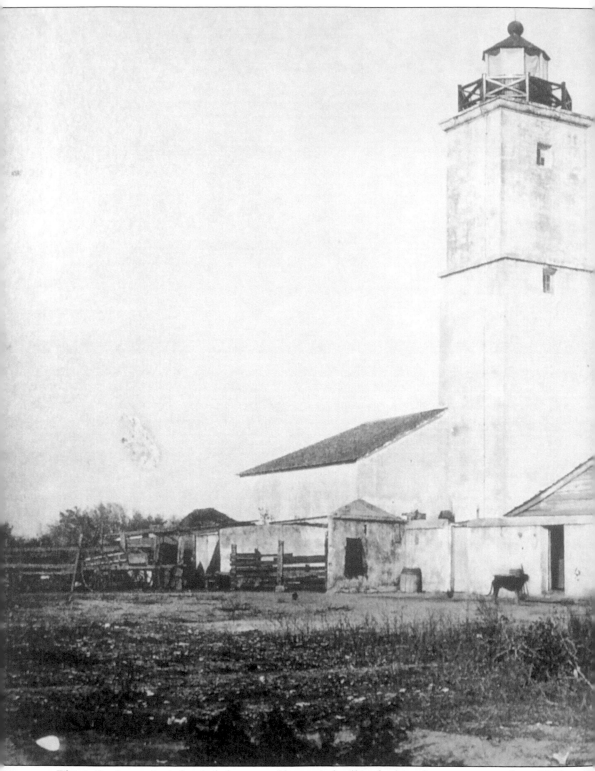

This is St. Augustine's first lighthouse and keeper's dwelling looking from east to north, c. 1860.

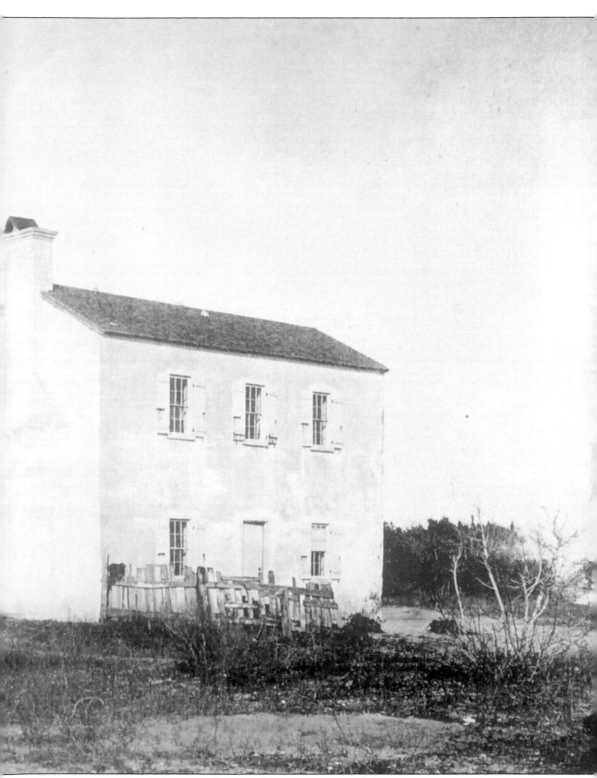

(Photo courtesy Florida State Archives and St. Augustine Lighthouse and Museum.)

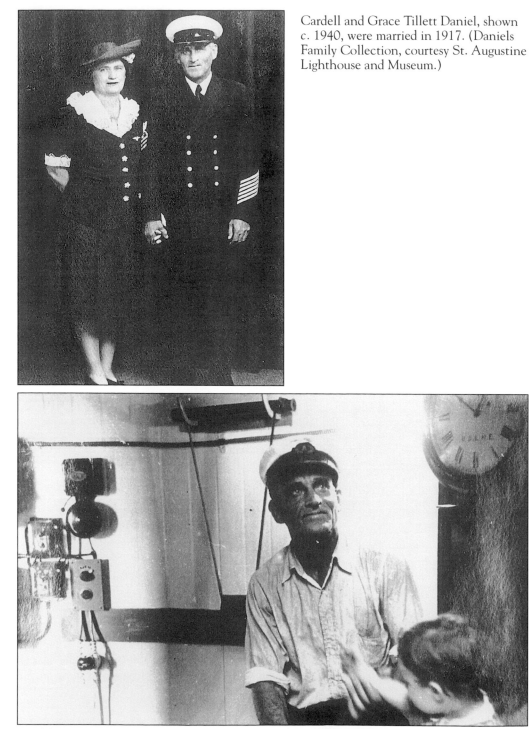

Cardell and Grace Tillett Daniel, shown c. 1940, were married in 1917. (Daniels Family Collection, courtesy St. Augustine Lighthouse and Museum.)

Cardell Daniels is inside the lens room of the St. Augustine Lighthouse with a young tourist, c. 1940. Daniels was second assistant at the St. Augustine Lighthouse from 1911 to 1914. He was later head lightkeeper from 1935 to 1943. (Daniels Family Collection, courtesy St. Augustine Lighthouse and Museum.)

Rachel Daniels and her brother, Elmer, pose at the St. Augustine light station in 1931. Their father was second assistant at the St. Augustine light station from 1926 to 1931, and again in 1933. (Photo courtesy Rachel Daniel Lightsey and the St. Augustine Lighthouse and Museum.)

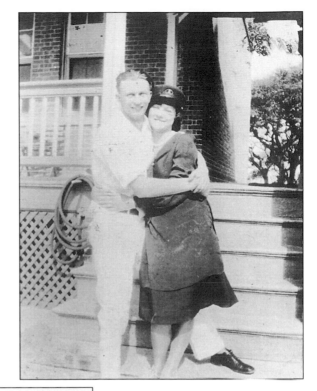

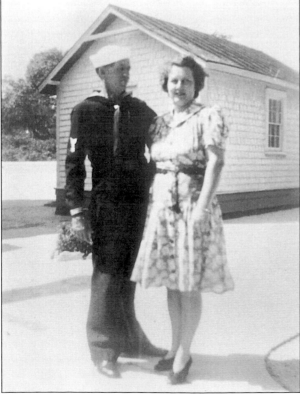

David Swain and his wife, Mary Etta, are shown at the Cape Canaveral Lighthouse, c. 1948. Swain was a keeper at Cape Canaveral from 1944 to 1952 and joined the U.S. Coast Guard there. Swain returned to St. Augustine, where he had been assistant keeper from 1933 to 1944. When the St. Augustine Lighthouse fully automated in 1955, the keeper's position was replaced by a "lamplighther," who was usually a local man who climbed the tower once a day to make sure everything was functioning properly. Swain served as the lamplighther at St. Augustine from 1955 to 1968. (Photo Jack Swain Ponce, courtesy St. Augustine Lighthouse and Museum.)

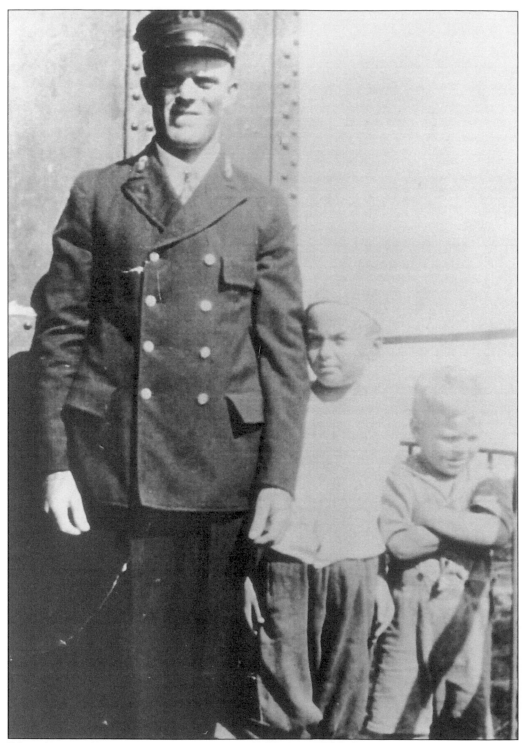

Edward Vance Hewitt and his sons, Bennie and Leon, are on the observation deck of the St. Augustine Lighthouse, c. 1922. Hewitt was second assistant keeper at St. Augustine from 1922 to 1924. (Photo by Edward Sheppard, courtesy St. Augustine Lighthouse and Museum.)

Two

PONCE DE LEON INLET TO CAPE FLORIDA

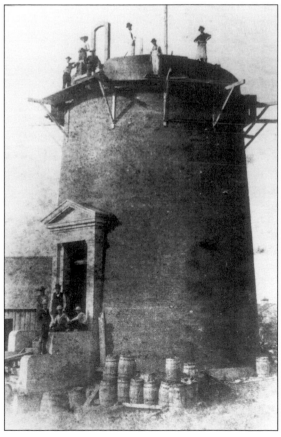

Workers took time out from their duties to pose for this photo of the Mosquito Inlet Lighthouse during the early stages of construction in the spring of 1887. (Association Collection, Ponce de Leon Inlet Lighthouse Preservation Association.)

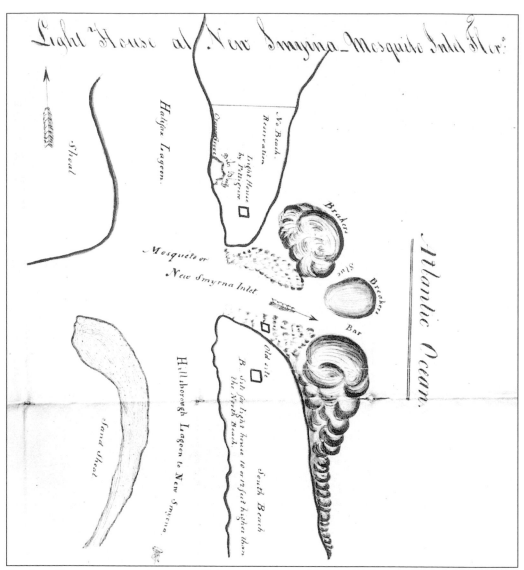

Stephen Pleasanton sent this map of Mosquito Inlet to Thomas Blake on July 14, 1842, asking that 5 to 10 acres on each side of the inlet be set aside for the use of a lighthouse. Interestingly, the map shows the location of the original lighthouse at this place, which washed into the sea. The first Mosquito Inlet Lighthouse was completed in February 1835, but was never lit. Two hurricanes in the fall of 1835 eroded the sand from around the base of the structure. Then, in the opening action of the Second Seminole War, Indian raiders, under the leadership of Coacoochee (or Wild Cat), burned the interior portions of the structure and absconded with portions of the lens. Finally, in April 1836, the structure collapsed into the sea.

Francis Hopkinson Smith was the engineer who designed the Mosquito Inlet Lighthouse. In addition to his engineering skill, Smith was also a noted writer. (Library of Congress photo, courtesy Ponce de Leon Inlet Lighthouse Preservation Association.)

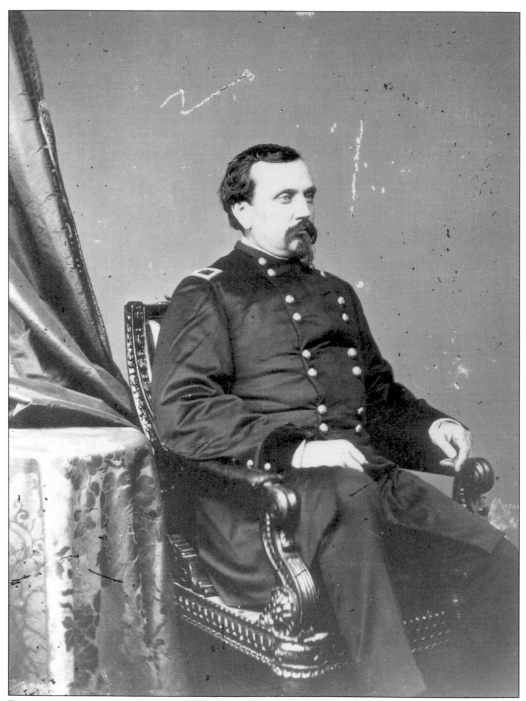

Brevet Brigadier General Orville E. Babcock was the man responsible for erecting the Mosquito Inlet Lighthouse. A native of Franklin, Vermont, Babcock gained prominence during the Civil War and finished the war as aid-de-camp to General Grant. Babcock died tragically at Mosquito Inlet before work on the lighthouse got underway. On June 2, 1884, the small boat he was riding in overturned in Mosquito Inlet, and Babcock drowned. (Library of Congress Photo, courtesy Ponce de Leon Inlet Lighthouse Preservation Association.)

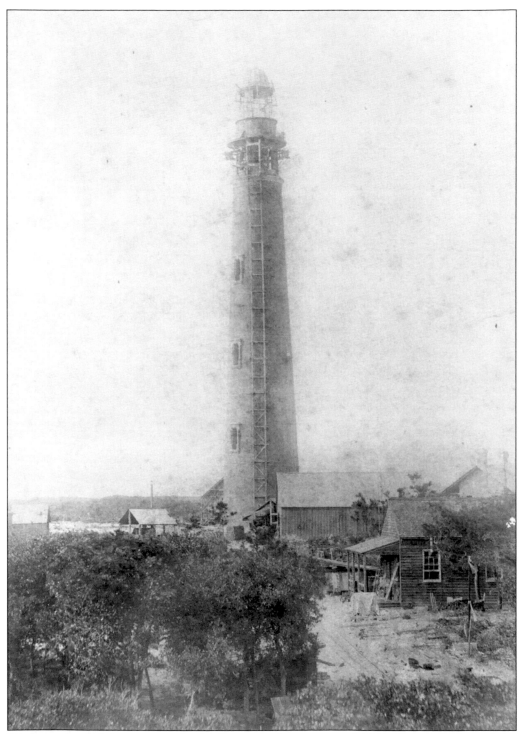

Work on the lighthouse neared completion in the summer of 1887. (Ponce de Leon Inlet Lighthouse Preservation Association.)

Here are the keepers of the Mosquito Inlet Lighthouse. Standing at left is Thomas Patrick O'Hagan, principal keeper of the Mosquito Inlet Lighthouse from 1893 to 1905. (O'Hagan Family Collection, Ponce de Leon Inlet Lighthouse Preservation Association.)

The children of lightkeeper Thomas O'Hagan and his wife, Julia, pose here in 1903. From left to right are (front row) Thomas, Joseph, Agnes, and Julia; (top row) Jane, twins Edith and William, Charlotte holding baby James, and Irene. (O'Hagan family Collection, Ponce de Leon Inlet Lighthouse Preservation Association.)

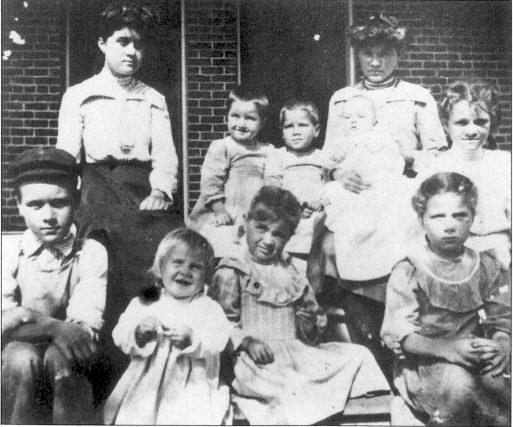

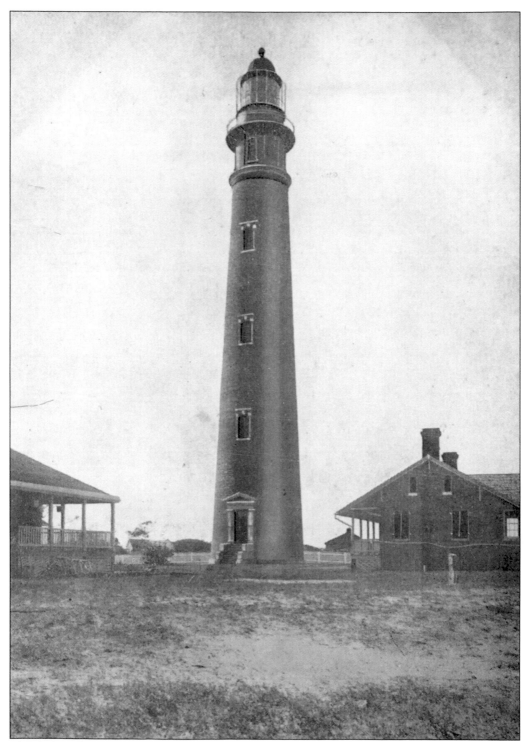

This postcard is of the Mosquito Inlet Lighthouse in 1907. (Florida State Archives.)

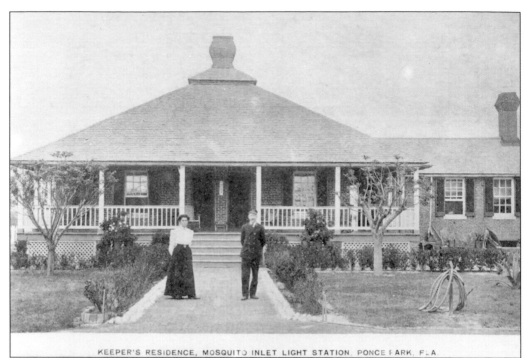

KEEPER'S RESIDENCE, MOSQUITO INLET LIGHT STATION, PONCE PARK, FLA.

Principal keeper John Lindquist and his wife, Ella Pomar Lindquist, are shown in front of the principal keeper's dwelling, c. 1915. Lindquist served as principal keeper at Mosquito Inlet from 1905 to 1924. (Association Collections, Ponce de Leon Inlet Lighthouse Preservation Association.)

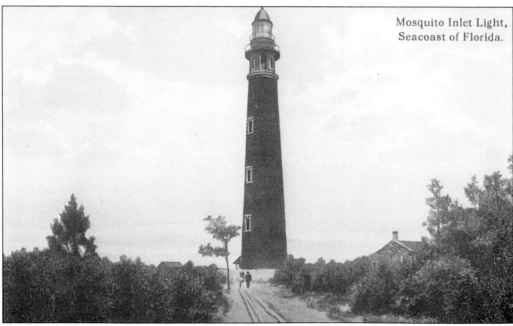

Mosquito Inlet Light, Seacoast of Florida.

Postcard view of the Mosquito Inlet Lighthouse. This is the tallest lighthouse in the state of Florida. (Florida State Archives.)

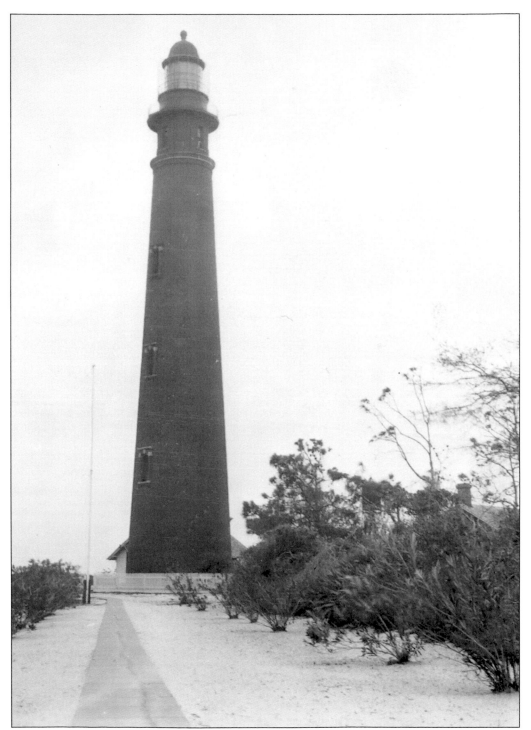

Ponce de Leon Inlet Lighthouse was photographed March 7, 1930. (Florida State Archives.)

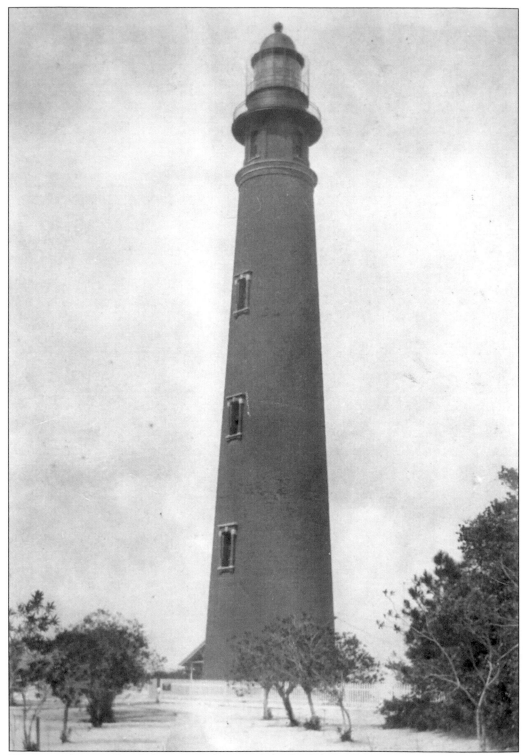

This is a photograph of the Ponce de Leon Inlet Lighthouse, c. 1929. Mosquito Inlet was renamed Ponce de Leon Inlet in 1927. (Florida State Archives.)

Principal keeper John Belton Butler is shown with his wife, Mamie. Butler served as principal keeper of the Ponce de Leon Lighthouse from 1926 to 1937. (Butler Family Collection, Ponce de Leon Inlet Lighthouse Preservation Association.)

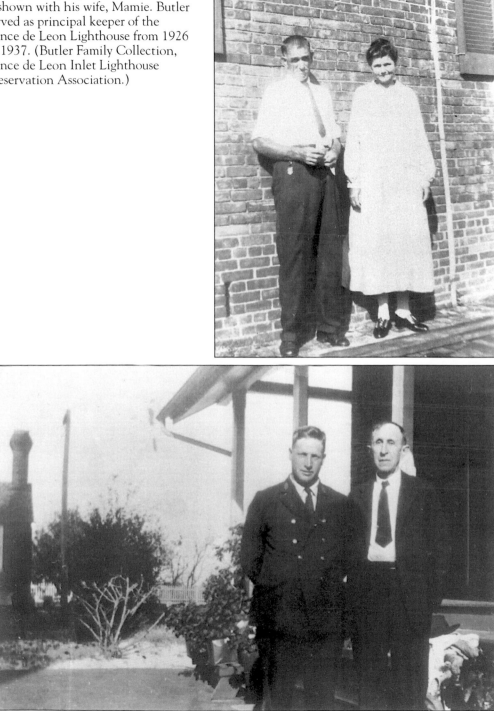

First assistant keeper Edward L. Meyer, shown here c. 1926, is the man on the left in this photo. He would later serve as principal keeper of the Ponce de Leon Inlet Lighthouse from 1937 to 1943. (Meyer Family Collection, Ponce de Leon Inlet Lighthouse Preservation Association.)

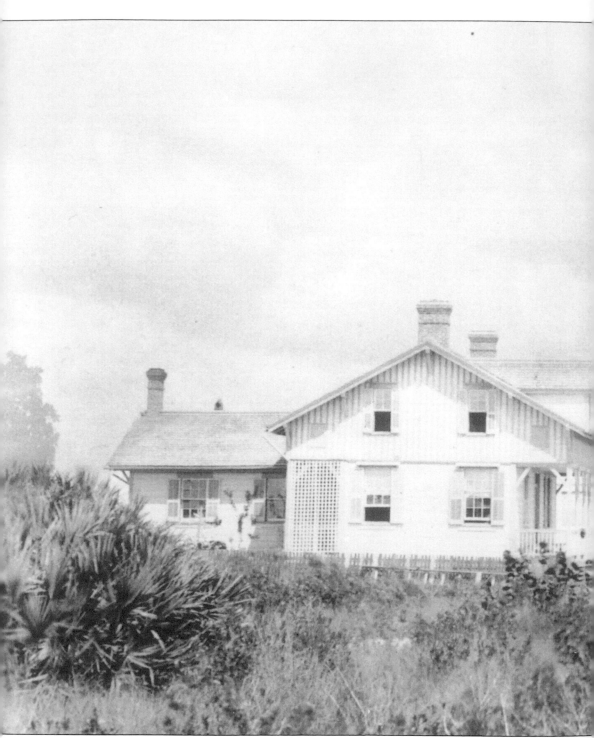

The Cape Canaveral Lighthouse was completed in 1868. The structure was the second lighthouse to be built at Cape Canaveral. The first lighthouse, constructed in 1848, was hard to see from the ocean and was often a hazard to navigation. A contract was signed to build a new, taller tower in 1860, but construction was delayed by the onset of the Civil War. In the

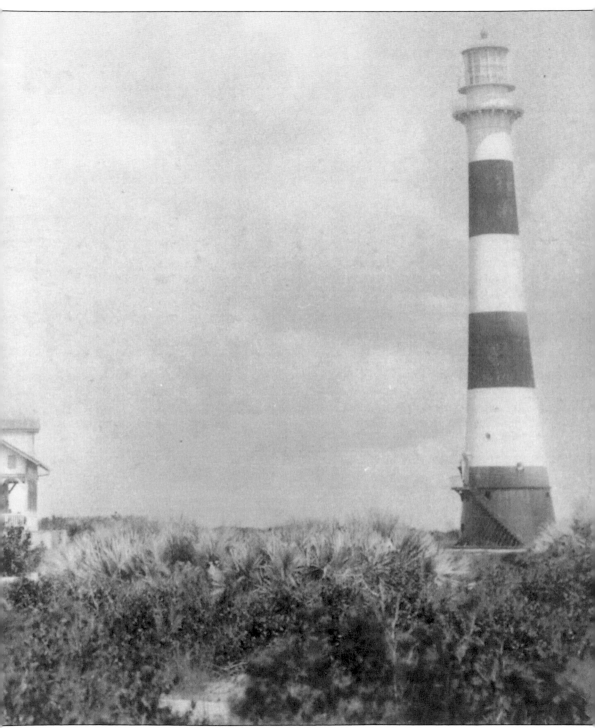

1880s, erosion of the shoreline threatened the lighthouse, so officials decided to move it. Work began in 1893, and by 1894, the structure was at its new location. The photo above shows the lighthouse before it was moved to its new location (National Archives.)

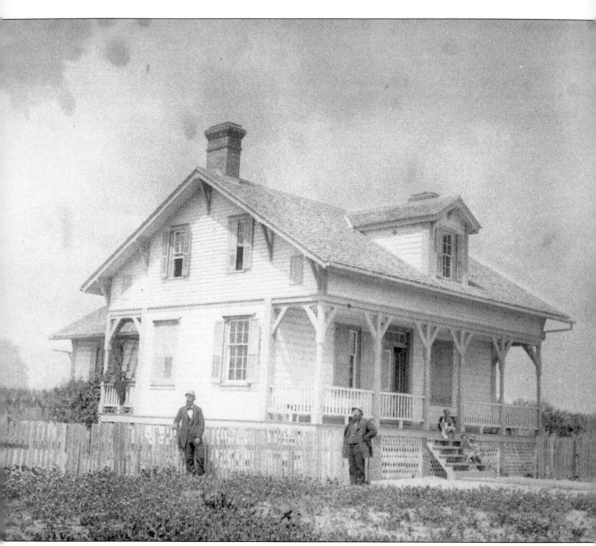

The assistant keeper's dwelling at Cape Canaveral is pictured, *c.* 1890. (National Archives.)

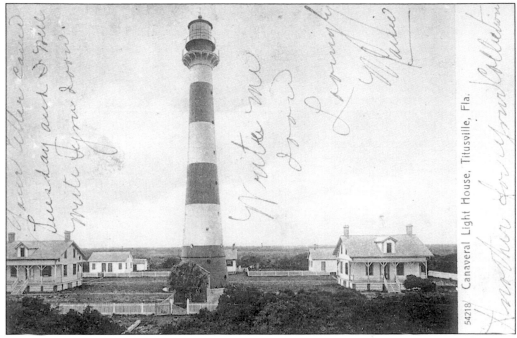

This old postcard, postmarked 1907, shows the "Cape Canaveral Lighthouse, Titusville, Fla." (Florida State Archives.)

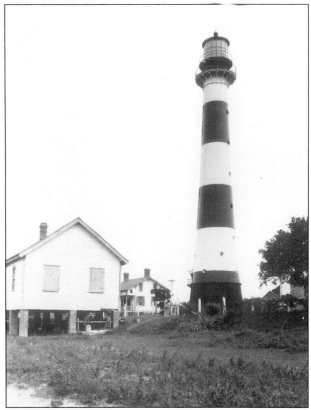

John Small took this photo of the Cape Canaveral Lighthouse in the 1920s. (Florida State Archives.)

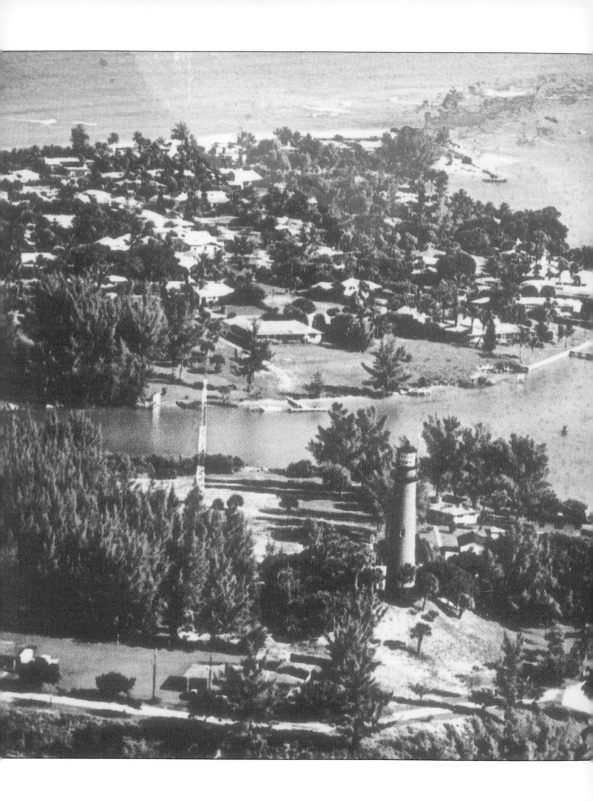

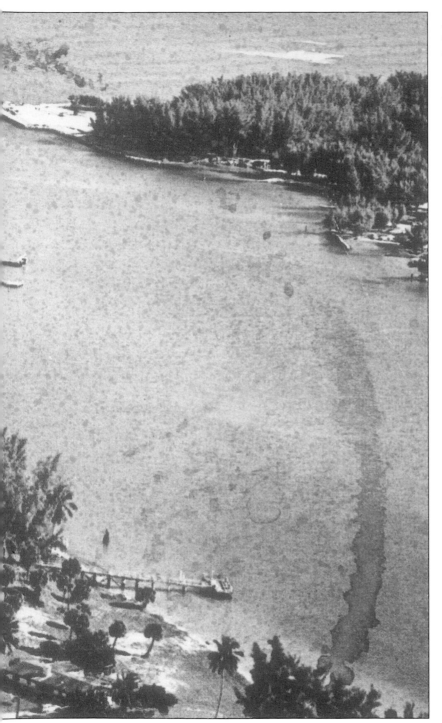

An aerial view of Jupiter Inlet shows the lighthouse. (Florida State Archives.)

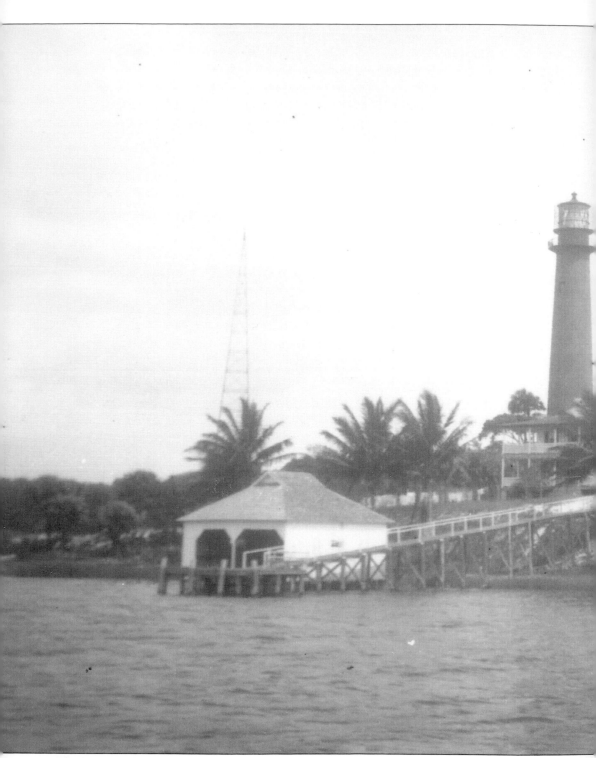

The Jupiter Inlet Lighthouse was first lit in July 1860, nearly nine years after a lighthouse at this spot had been proposed. Delays were the result of numerous factors, not the least of which was

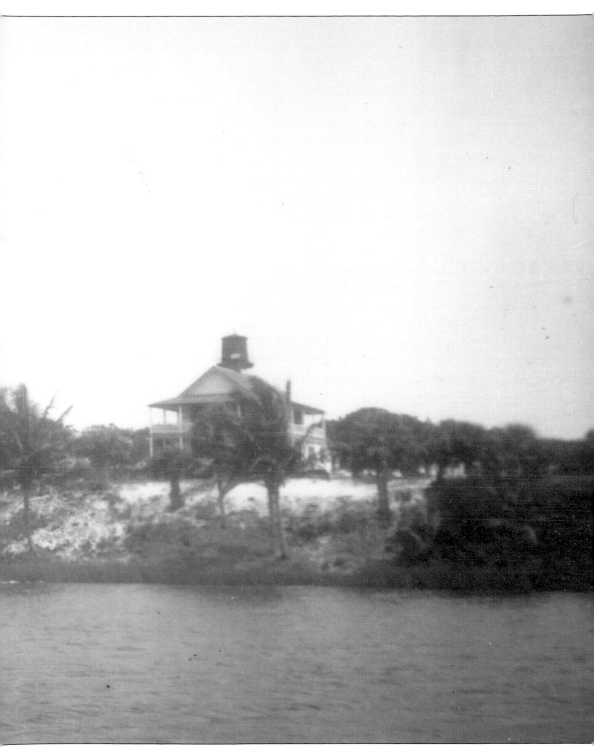

the closing of Jupiter Inlet. This necessitated the ferrying of supplies from Indian River to Jupiter Inlet. This photo of the Jupiter Inlet Lighthouse was taken in 1915. (Florida State Archives.)

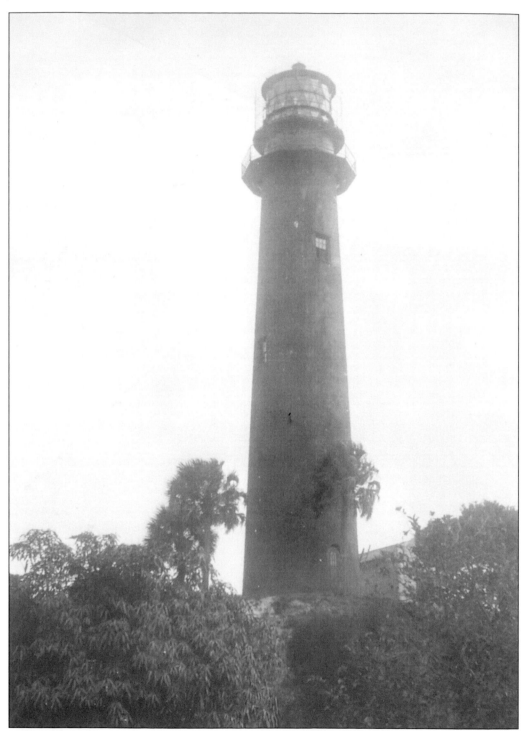

D. Stuart Mossom of the Florida Geological Survey captured this image of the Jupiter Inlet Lighthouse in January of 1924. (Florida State Archives.)

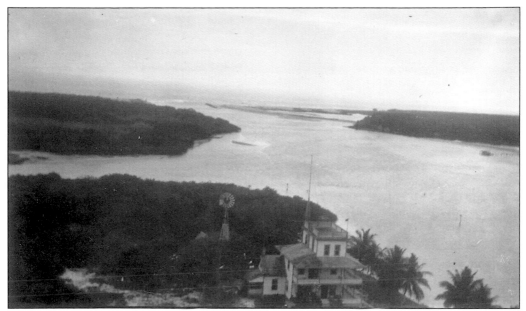

Mossom captured this image of Jupiter Inlet from atop the lighthouse in January of 1924. (Florida State Archives.)

Mossom took this photo of Hobe Sound from atop the Jupiter Inlet Lighthouse. (Florida State Archives.)

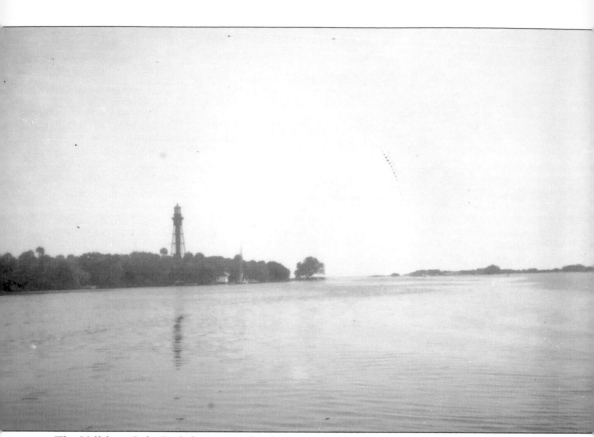

The Hillsboro Inlet Lighthouse was first lit in 1907. The cast-iron structure was built in Chicago and displayed at the 1904 St. Louis Exposition, before being shipped to Pompano Beach, Florida. (Florida State Archives.)

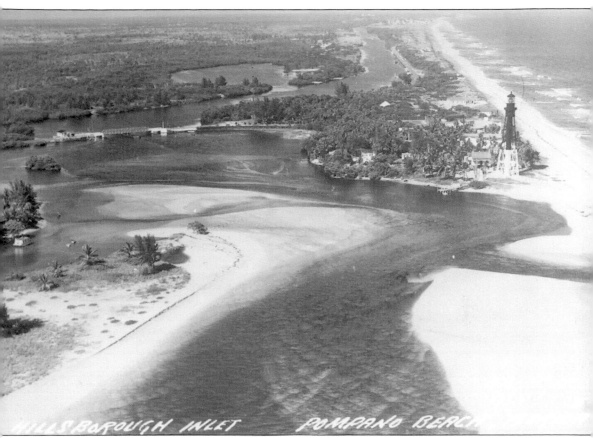

An aerial view of Hillsboro Inlet, taken in 1942, shows the lighthouse on the north side of the inlet. (Florida State Archives.)

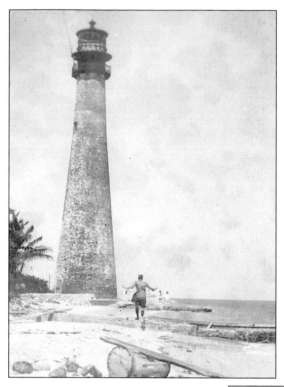

Visitors enjoying the sun and surf at Cape Florida in 1915. (Florida State Archives.)

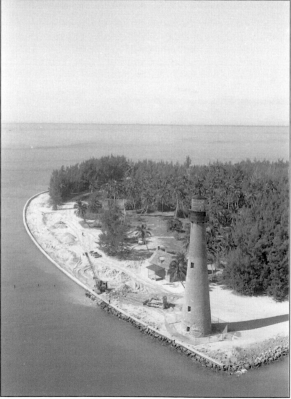

The Cape Florida Lighthouse stands as the focal point of Bill Baggs State Recreation Area. The park takes its name from Bill Baggs, a newspaper editor from Miami, who was the driving force behind preserving the Cape Florida Lighthouse for future generations. (Florida State Archives.)

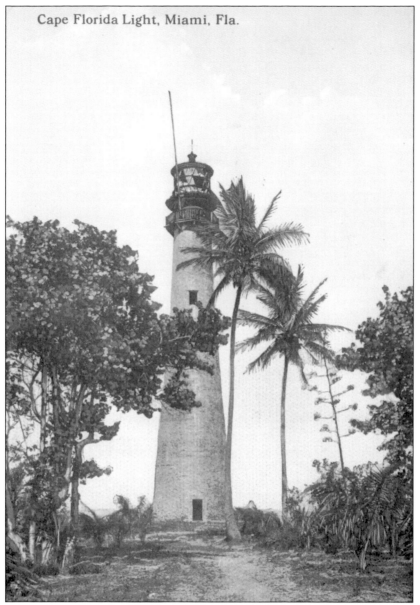

Cape Florida Light, Miami, Fla.

A lighthouse at Cape Florida was originally constructed in 1825. On July 23, 1836, during the Second Seminole War, the lighthouse was attacked by a group of Seminoles, who severely damaged the structure with fire and bullets. Lightkeeper John Thompson was seriously wounded in the attack, and his assistant Aaron Carter was killed. The two had sought refuge from their attackers on the top of the lighthouse. Thompson was rescued the next day by the crew of a U.S. Navy ship, who had to use ropes to get the wounded man down, as the wooden stairs had been consumed in the blaze.

The current lighthouse was constructed in 1847 to replace the damaged first light. This light operated until August of 1861, when part of the lens was destroyed during the early days of the Civil War. It was re-lit in 1867 but discontinued in June of 1878, with the completion of the nearby Fowey Rocks Lighthouse. This postcard shows the Cape Florida Light as it appeared, c. 1920. (Florida State Archives.)

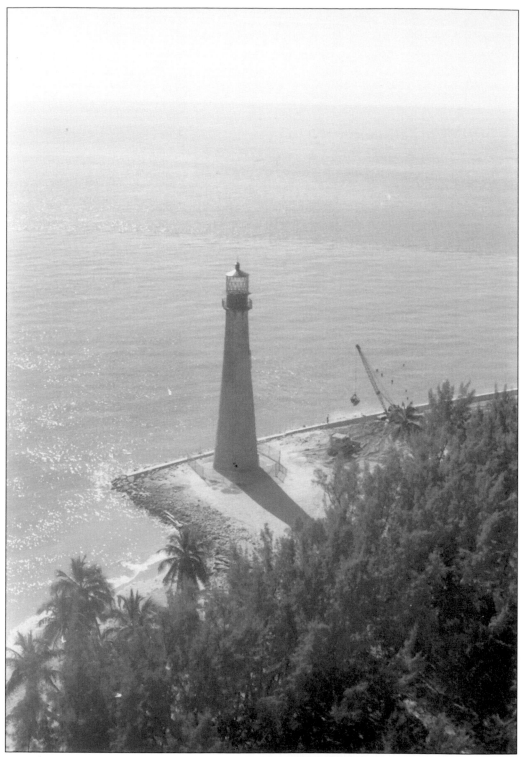

On July 15, 1978, exactly one century after being extinguished, the Cape Florida Lighthouse was put back in operation by the U.S. Coast Guard. (Florida State Archives.)

Three

THE FLORIDA KEYS

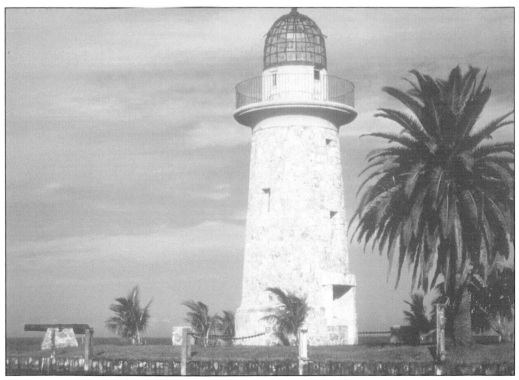

Though not an official lighthouse, this tower on Boca Chita Key is a prominent landmark for visitors to Biscayne National Underwater Park. Mark Hopewell, who owned Boca Chita Key, had a 65-foot-tall limestone tower constructed as a private lighthouse, c. 1940. Since it was not an official aid to navigation, the Bureau of Lighthouses instructed Honeywell not to illuminate his lighthouse. (National Park Service Photo.)

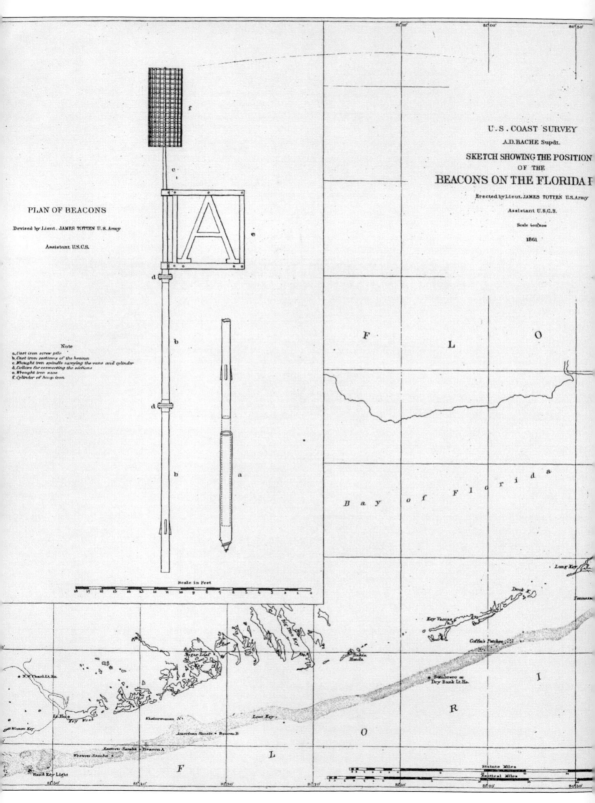

PLAN OF BEACONS

Devised by Lieut. JAMES TOTTEN U.S.Army

Assistant U.S.C.S.

Note
a. Cast iron screw pile
b. Cast iron sections of the beacon
c. Wrought iron spindle carrying the vane and cylinder
d. Collars for connecting the sections
e. Wrought iron vane
f. Cylinder of hoop iron

Scale in Feet

U.S. COAST SURVEY

A.D. BACHE Supdt.

SKETCH SHOWING THE POSITION

OF THE

BEACONS ON THE FLORIDA R

Erected by Lieut. JAMES TOTTEN U.S.Army

Assistant U.S.C.S.

Scale 1∕40000

1861

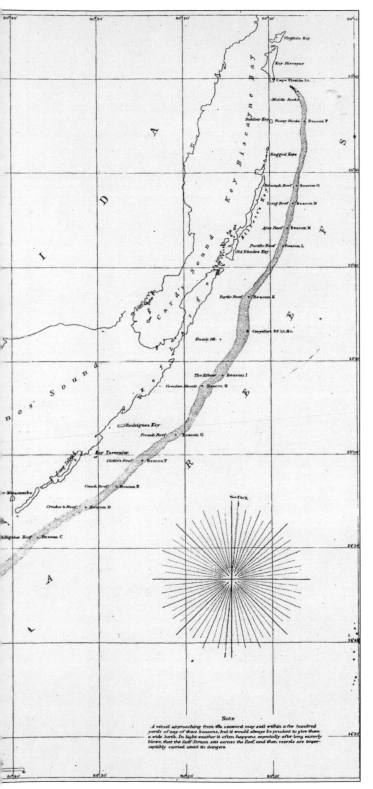

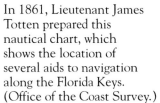

In 1861, Lieutenant James Totten prepared this nautical chart, which shows the location of several aids to navigation along the Florida Keys. (Office of the Coast Survey.)

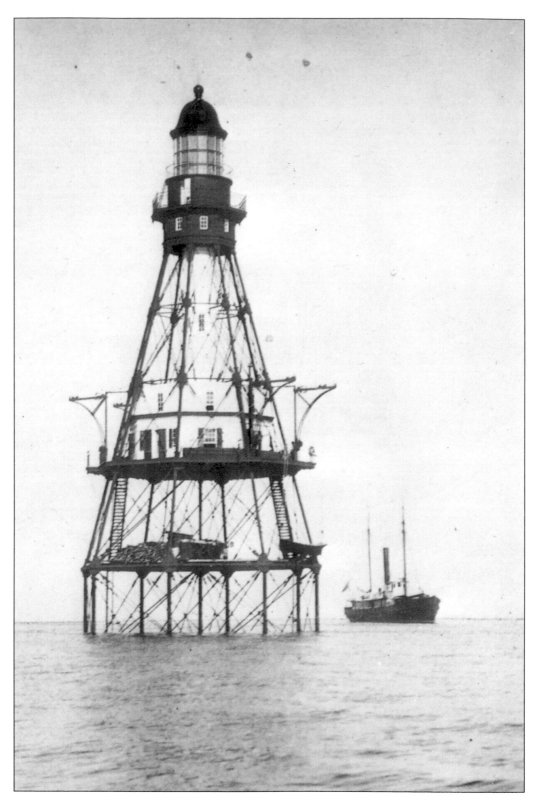

Opposite page: The Fowey Rocks Lighthouse was constructed on the northernmost portion of the Florida Reef beginning in 1875. While workers were assembling the pre-fabricated structure, two ships wrecked on Fowey Rocks. On June 15, 1878, the Fowey Rocks Lighthouse was first illuminated. Ships bound for the port of Miami found the Fowey Rocks Lighthouse a much more reliable aid to navigation than the nearby Cape Florida Lighthouse. The Fowey Rocks Lighthouse is sometimes referred to as, "The Eyes of Miami." (Florida State Archives.)

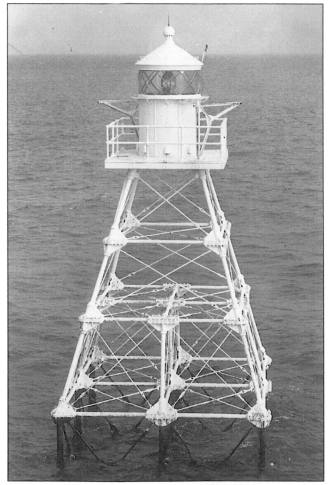

This image is of the Pacific Reef Light. (Florida State Archives.)

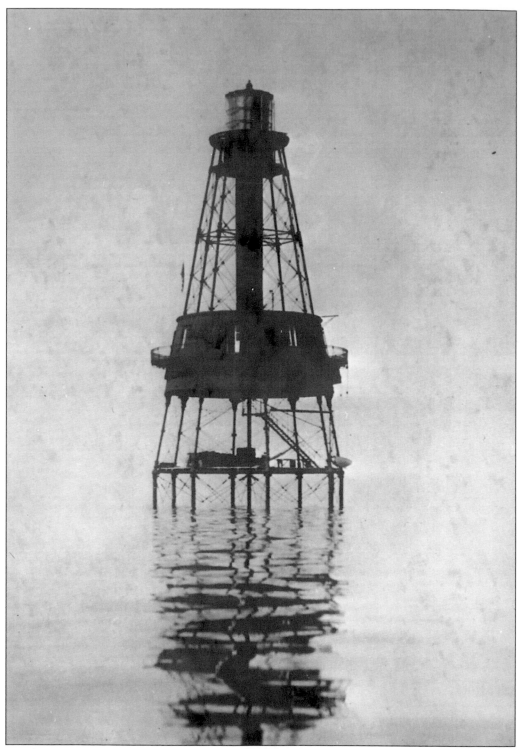

First lit in March of 1852, the 100-foot-tall iron Carysfort Reef Lighthouse replaced a series of lightships that marked a dangerous section of the Florida Reef. (Florida State Archives.)

The U.S.S. *Alligator* wrecked on a reef off the Florida Keys on the night of November 19, 1822. Ever after, the reef became known as Alligator Reef. Just 10 days earlier, the *Alligator's* commander, Lieutenant William H. Allen, was killed off the coast of Cuba in the closing scenes of a battle with pirates. (Florida State Archives.)

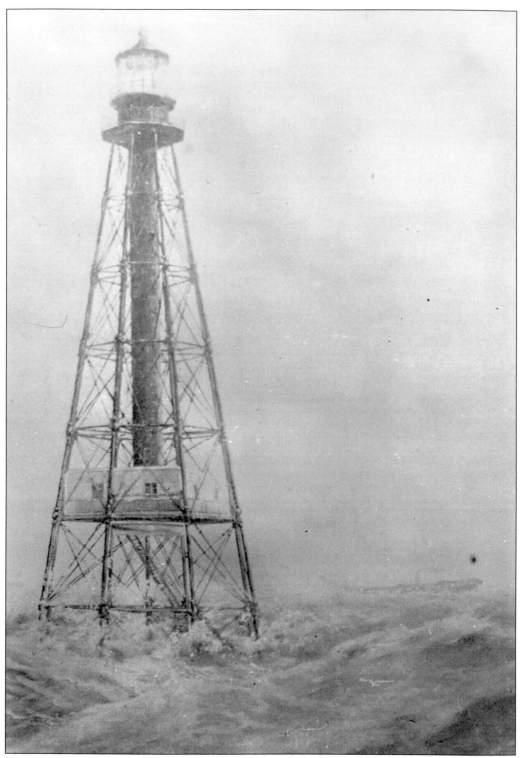

The Alligator Reef Lighthouse is shown here in a photo taken shortly after it was first lit on November 23, 1873. The iron lighthouse cost $185,000 to build. (Florida State Archives.)

Lieutenant General George Meade is best remembered as the Union commander during the Battle of Gettysburg in July 1863. However, in the years before the Civil War, Meade supervised the completion of several lighthouses along the coast of Florida. (Library of Congress.)

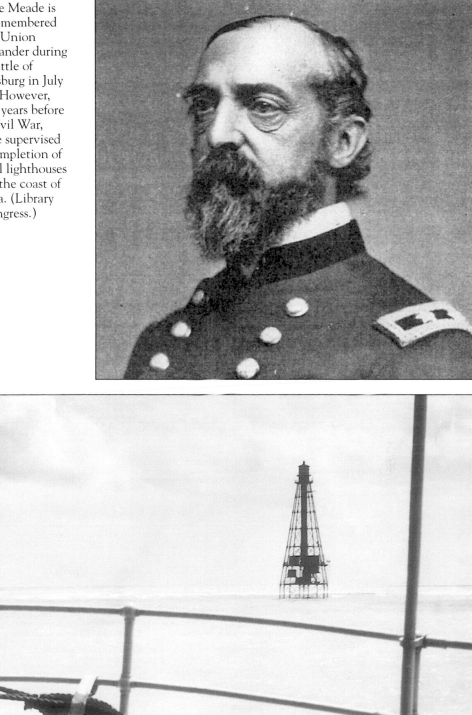

The Sombrero Key Lighthouse is seen from the deck of an approaching ship. The lighthouse was automated in 1963. (U.S. Coast Guard photo.)

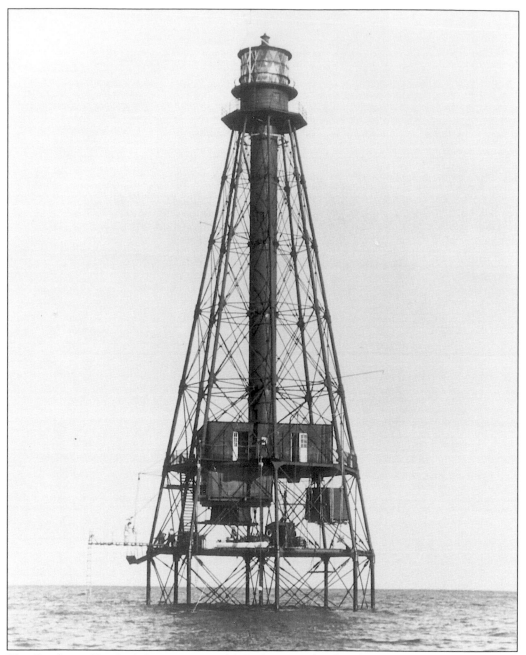

The Sombrero Key Lighthouse was established in March of 1858. It was the last of the iron lighthouses erected along Florida Reef to be built under the direction of George Meade. The Sombrero Key Lighthouse was the tallest of the lighttowers established along the keys, standing 142 feet above the water. (U.S. Coast Guard Photo.)

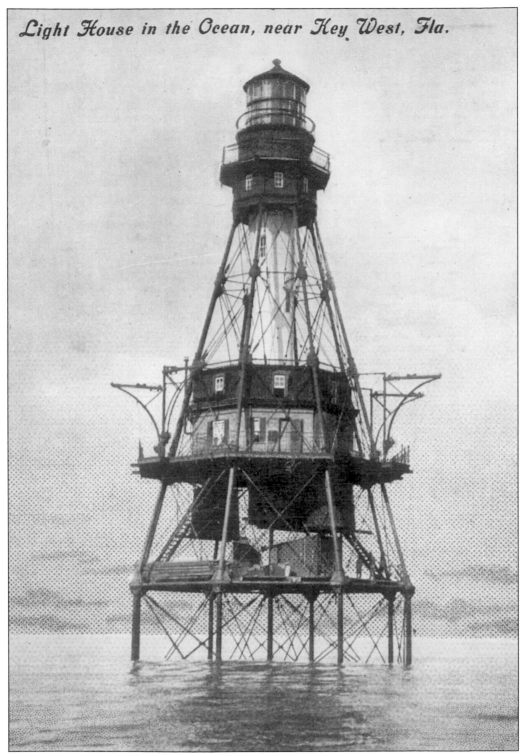

Light House in the Ocean, near Key West, Fla.

American Shoal Lighthouse was first lit on July 15, 1880. The iron lighthouse stands 109 feet tall and can be seen up to 16 miles away. (Florida State Archives.)

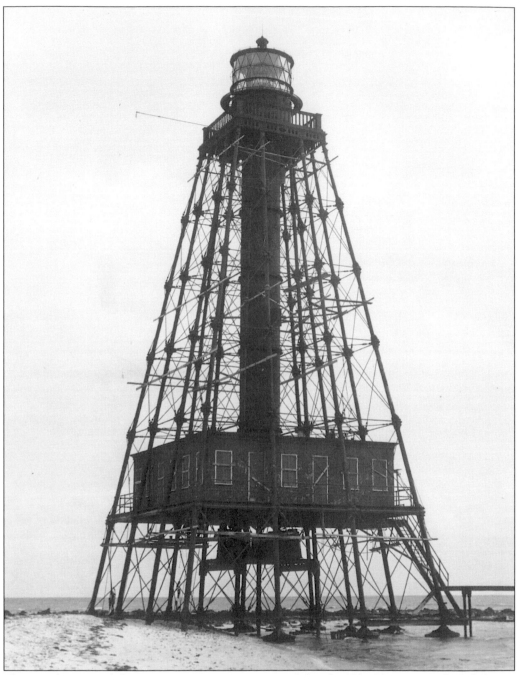

The Sand Key Lighthouse went into operation in July of 1853. This screwpile lighthouse stands 132 feet tall and was cast by the John F. Riley Ironworks of Charleston, South Carolina. A lighthouse had been constructed on Sand Key in 1826, but it was destroyed during the same hurricane that destroyed the first Key West Lighthouse on October 10, 1846. (U.S. Coast Guard Photo.)

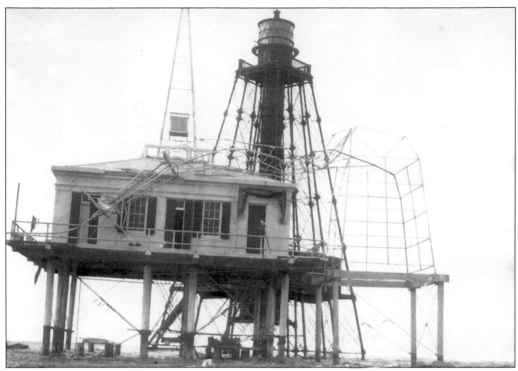

The weather station that stood on Sand Key beside the lighthouse was severely damaged by a hurricane in 1919. An earlier weather station had been swept from the island during a hurricane in October of 1909. (Florida State Archives.)

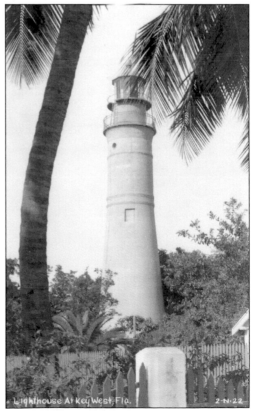

Lighthouse At Key West, Fla. 2-N-22

This old postcard shows the Key West Lighthouse, which stands 86 feet tall. The old structure is now the focal point of the Key West Lighthouse Museum.

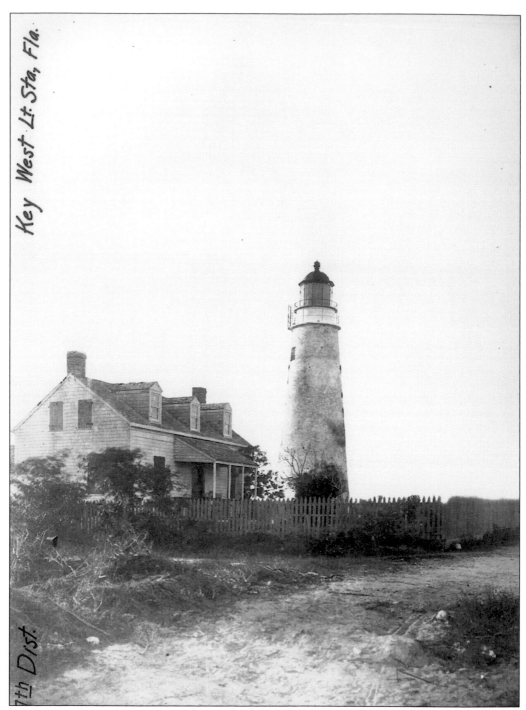

Key West Lt. Sta., Fla.

7th Dist.

A lighthouse has stood on Key West since 1825, when the first one was completed on Whiteheads Point. The original Key West Lighthouse was destroyed by a hurricane on October 10, 1846, and in 1848, it was replaced by the current structure shown above. (National Archives.)

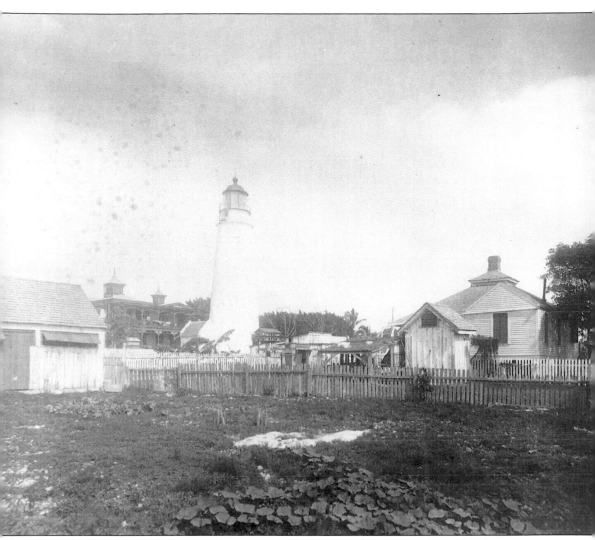

This is the Key West Lighthouse and surrounding buildings as they appeared in 1892. A notation on this photo notes, "Key West Lt. Sta. Before raising." This is a reference to the addition of 20 feet to the tower in 1894. (National Archives.)

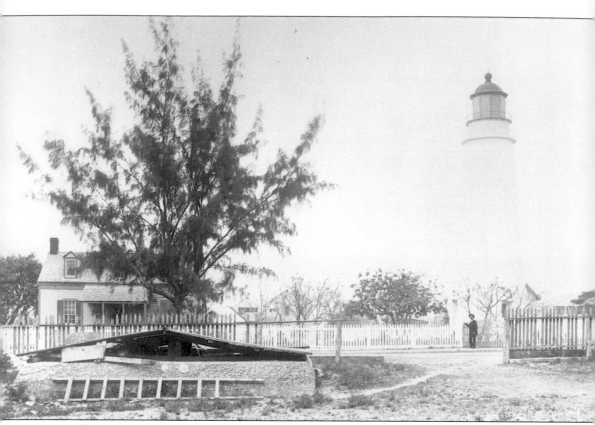

Another view, also taken in 1892, shows the Key West Lighthouse. (National Archives.)

This card, postmarked 1938, proclaims, "Only Lighthouse In U.S. Within City Limits." (Florida State Archives.)

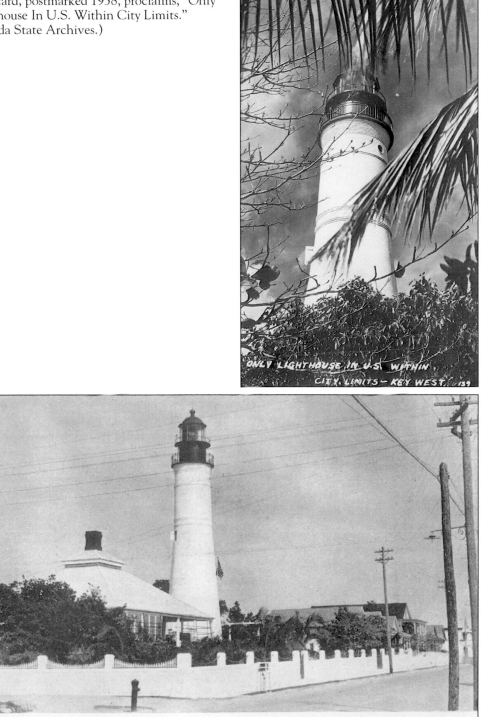

The lighthouse and keeper's quarters are shown on this photo taken in 1923. (Florida State Archives.)

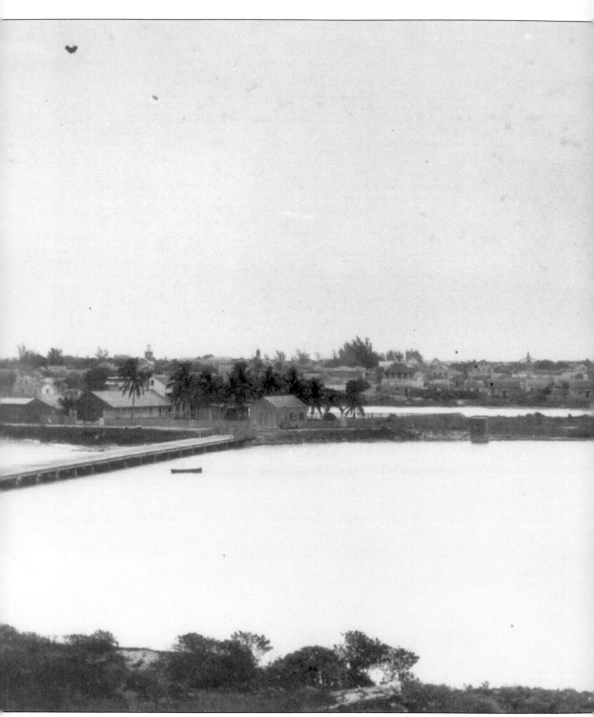

This panoramic view of Key West was taken c. 1890. The Key West Lighthouse can be seen

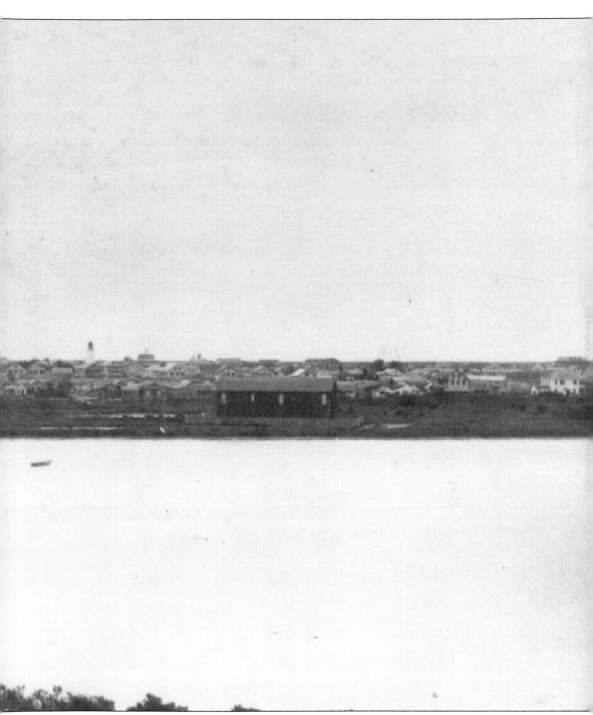

looming above the skyline just to the right of center. (Library of Congress.)

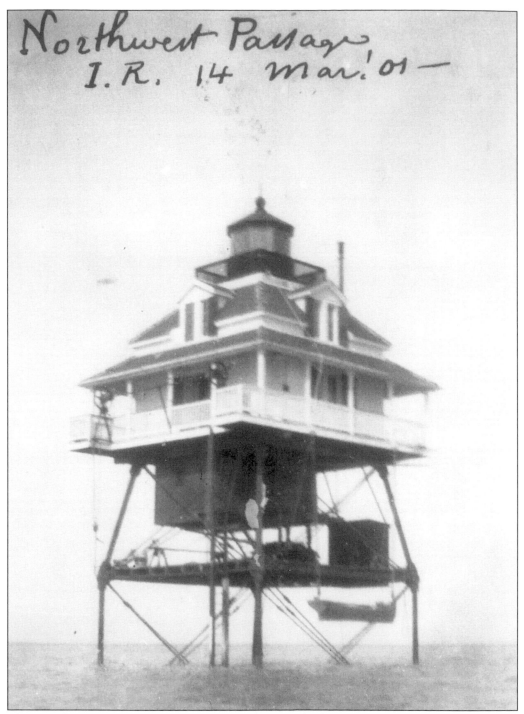

Northwest Passage
I.R. 14 mar. 01 —

The Northwest Passage Lighthouse was photographed on March 14, 1901. The light marked an important channel into Key West. A lightship and lighthouse preceded the above structure, which was built in 1879. Though decommissioned in 1921, the Northwest Passage Lighthouse remained a prominent locale until it was destroyed by fire on August 30, 1971. (National Archives.)

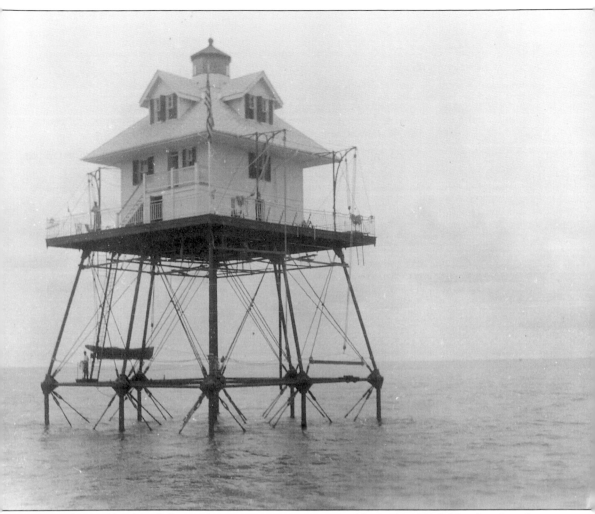

The Rebecca Shoal Lighthouse first went into operation in November 1886. The fourth order Fresnell lens was mounted on top of the keeper's quarters, which was built on an iron platform above the water. The structure was dismantled in 1953. (U.S. Coast Guard photo.)

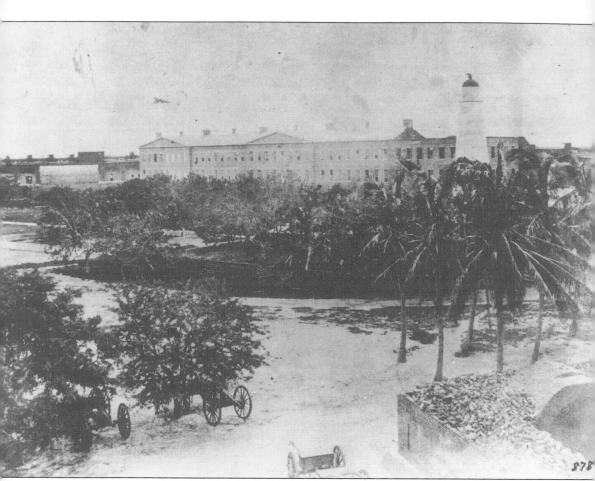

This photo shows the Garden Key Lighthouse in the Dry Tortugas, c. 1870. (U.S. Coast Guard photo.)

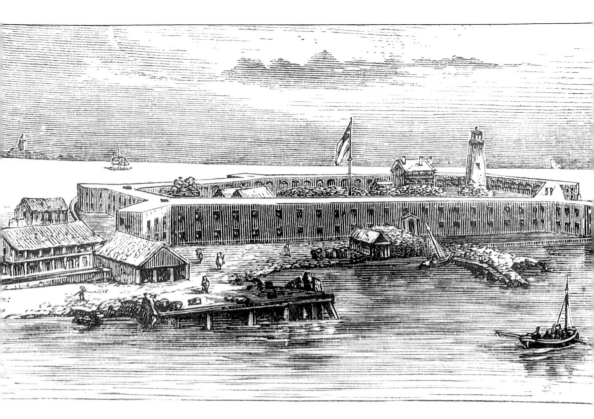

FORT JEFFERSON.

The Garden Key Lighthouse first went into operation on July 4, 1826. In December of 1846, construction began on Fort Jefferson, and soon the brick walls of this fort enclosed most of Garden Key. As shown in this sketch, the lighthouse and keeper's quarters occupied a prominent spot within the fort.

In 1858, the Garden Key Lighthouse was downgraded to the status of harbor light, thanks to the lighting of another, more powerful light on nearby Loggerhead Key. The newer lighthouse can be seen in the left background of the above sketch.

The Garden Key Lighthouse remained operational until the mid-1870s, when continued battering from hurricanes damaged the lighthouse beyond repair. In 1876, a new iron structure was built, and the old Garden Key Lighthouse was demolished shortly thereafter. (Florida State Archives.)

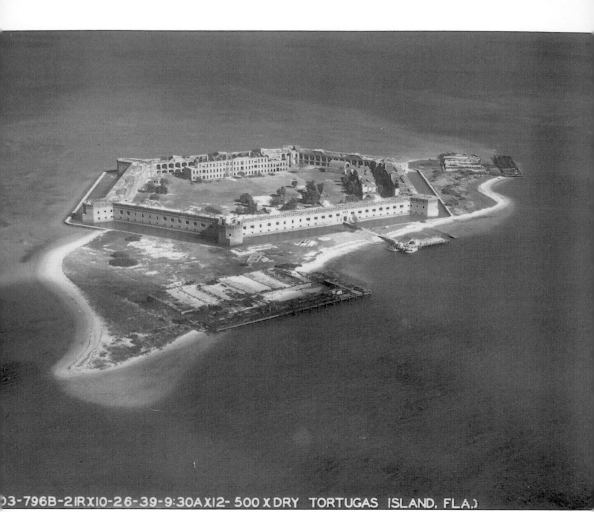

03-796B-2 IRX 10-26-39-9:30A X 12- 500 X DRY TORTUGAS ISLAND, FLA.

The location of the Tortugas Harbor Light is visible on this aerial photo taken of Fort Jefferson in 1940. This light was constructed of boilerplate iron in 1876. (Florida State Archives.)

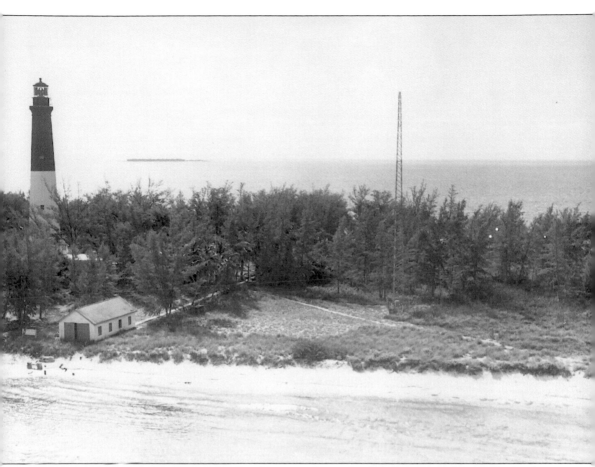

This view of Loggerhead Key in the Dry Tortugas shows the lighthouse on this small island.
(Florida State Archives.)

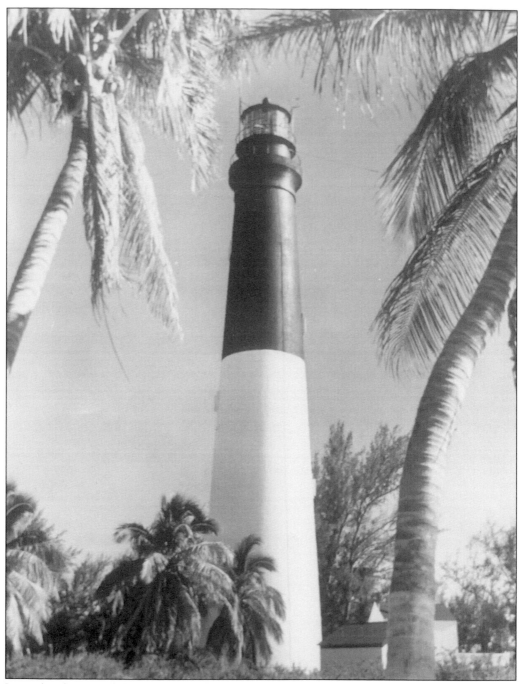

Loggerhead Key Lighthouse was completed in 1858. The brick tower stands 150 feet tall. The lighthouse was built here to guide ships around the dangerous reefs in the Dry Tortugas and into the Gulf of Mexico.

Historian David Cipra noted, "This lighthouse marking the entrance to the Gulf of Mexico became the most powerful in the United States in 1931 when a three-million-candlepower electric light was switched on, about 250 times the intensity of the kerosene lamps it replaced." (Florida State Archives.)

Four

SANIBEL ISLAND TO CEDAR KEY

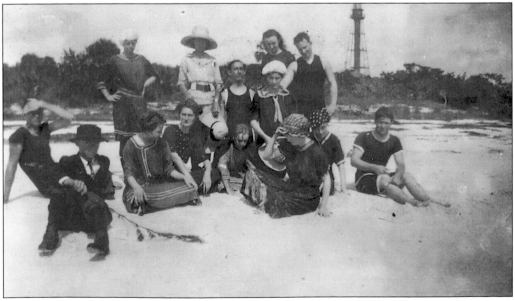

Teachers from the Andrew D. Gwynne Institute in Fort Myers enjoyed a day at the beach on Sanibel Island in 1913. Note the lighthouse in the background. (Florida State Archives.)

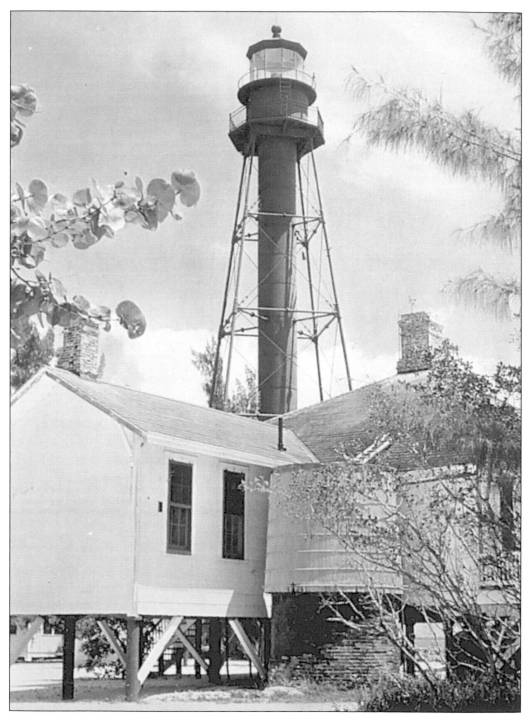

An old postcard shows the lighthouse on Sanibel Island. First lit in August of 1884, the lighthouse had a stormy birth. The iron structure was originally built in New Jersey. While en route to Sanibel Island, the ship carrying this lighthouse and the lighthouse for Cape San Blas sank off Sanibel Island. The iron structures were salvaged and soon put into operation at their respective locales.

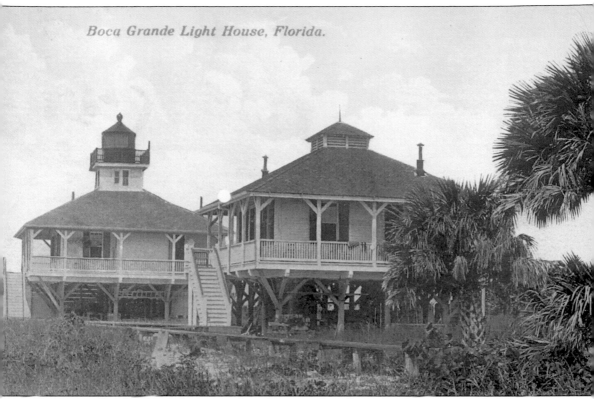

Boca Grande Light House, Florida.

The Gasparilla Island Lighthouse was first illuminated on December 31, 1890. The lighthouse was sometimes called the Boca Grande Lighthouse, as evidenced from this turn-of-the-century postcard. The structure on the left, with the light apparatus on the roof, was the keeper's quarters. The building on the right was the assistant keeper's quarters. (Florida State Archives.)

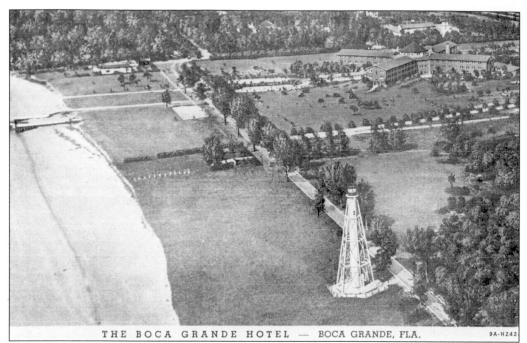

This postcard of the Boca Grand Hotel gives an aerial view of the Boca Grande Rear Range Lighthouse. Constructed in 1932, the structure was built primarily as an aid to local mariners. (Florida State Archives.)

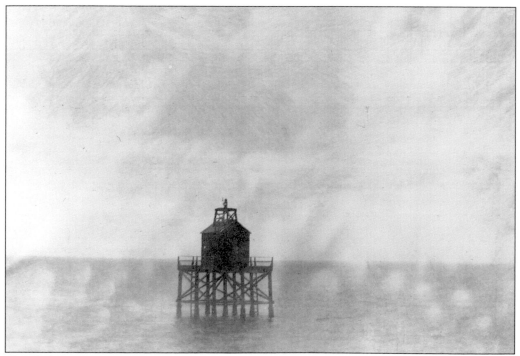

This light on Mangrove Point marked the upper reaches of Charlotte Harbor. (U.S. Coast Guard photo.)

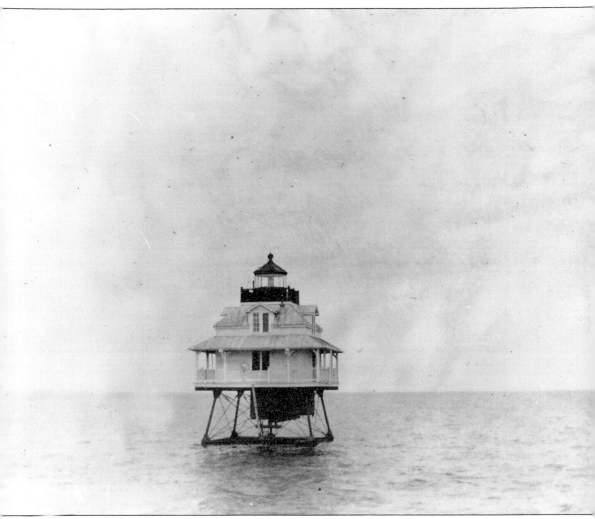

This wooden structure was constructed in Charlotte Harbor in 1890. The lighthouse was 10 feet above the water, and its light was visible for approximately 10 miles. (U.S. Coast Guard Photo.)

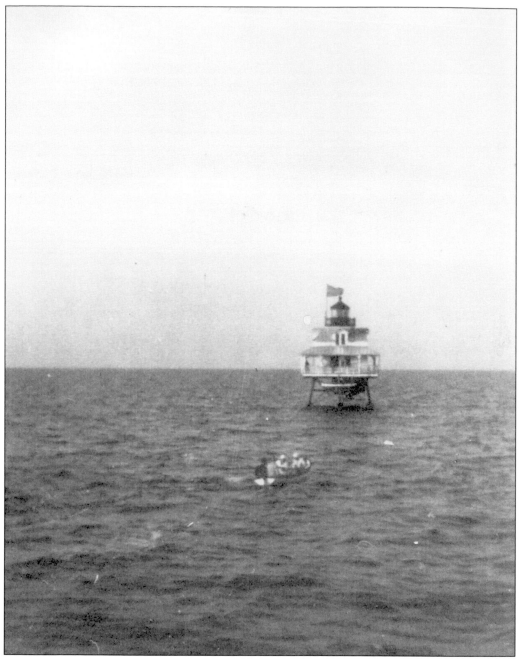

The individuals in the boat were heading out to the Charlotte Harbor Lighthouse in 1911. In 1918, the lighthouse became an unmanned station. As its usefulness declined, the structure was eventually demolished in 1943. (National Archives.)

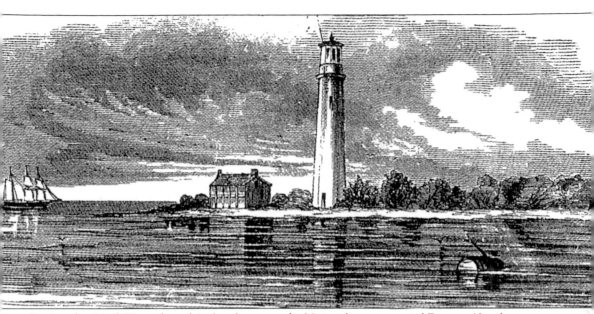

During the Civil War, when this sketch was made, Union forces occupied Egmont Key, but not before lightkeeper George Rickard carted up the lens and hid it safely on the mainland near Tampa. Throughout the war, Union sympathizers found refuge on Egmont Key. The island also housed Confederate prisoners. (Florida State Archives.)

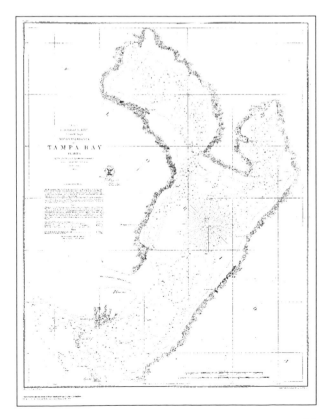

Reconnaissance of Tampa Bay Florida, by Lieutenant O.H. Berryman, was drawn in 1855. This nautical chart clearly shows the location of the lighthouse in Egmont Key at the mouth of Tampa Bay.

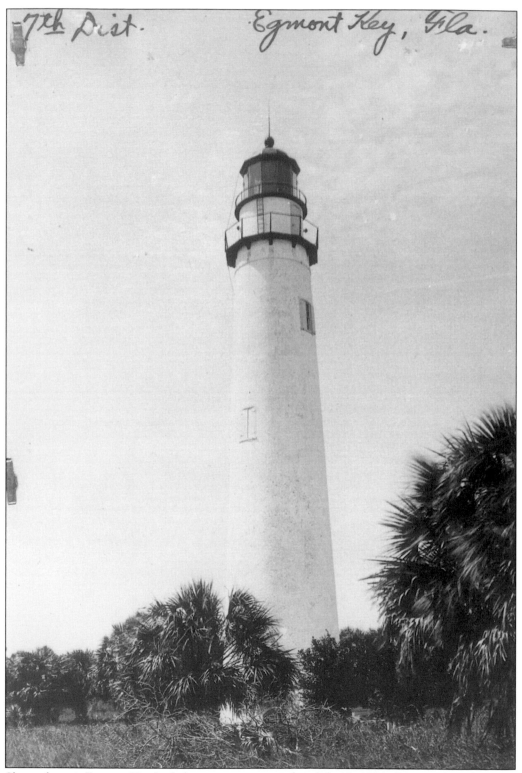

Shown here is Egmont Key Lighthouse, as it appeared on July 18, 1890. (National Archives.)

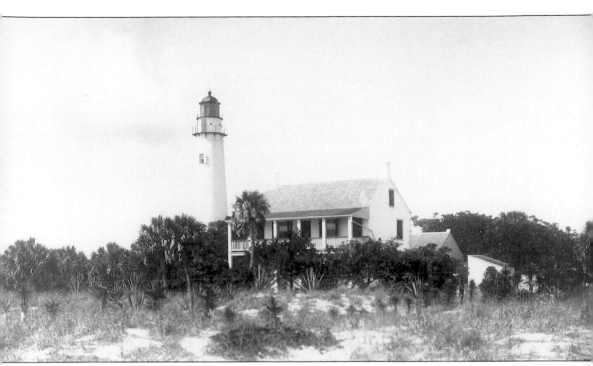

This photo, taken in 1892, gives a good view of the lightkeeper's quarters on Egmont Key. (National Archives.)

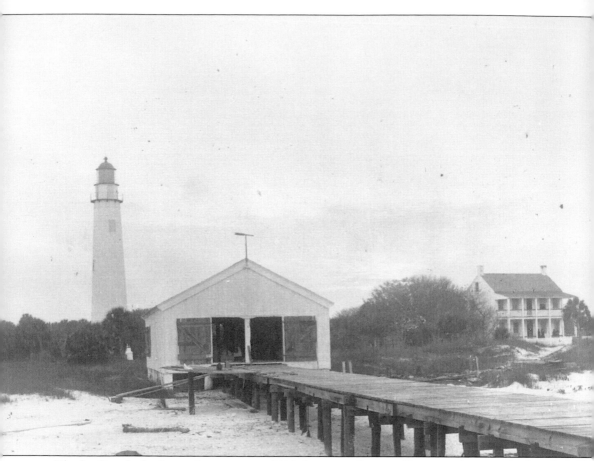

The loading docks, keeper's quarters, and lighthouse on Egmont Key were photographed in the summer of 1892. (National Archives.)

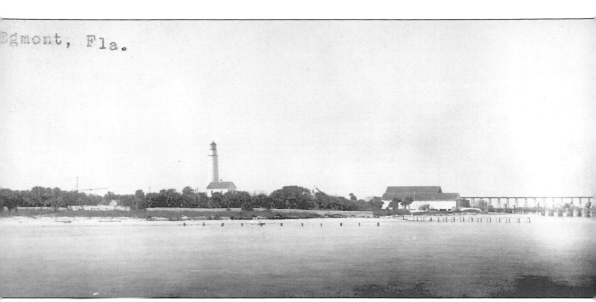

Prior to World War II, the dock facilities on Egmont Key were expanded. (Florida State Archives.)

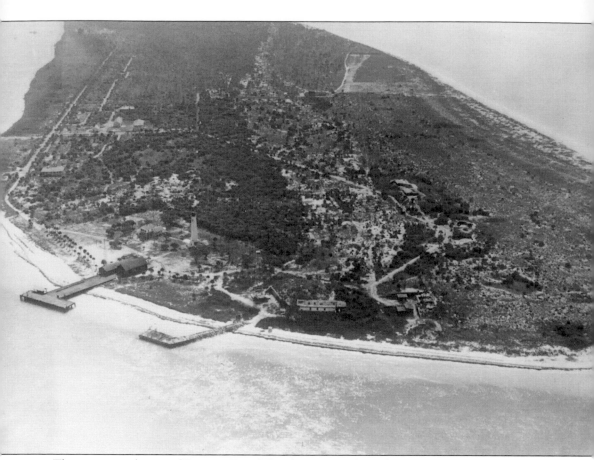

This is an aerial view of Egmont Key. (Florida State Archives.)

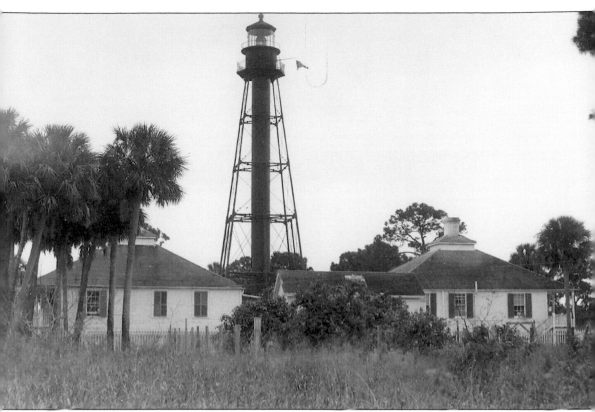

The Anclote Keys Lighthouse was first lit on September 15, 1887. The two wooden structures were homes for both the lightkeeper and his assistant. (U.S. Coast Guard Photo.)

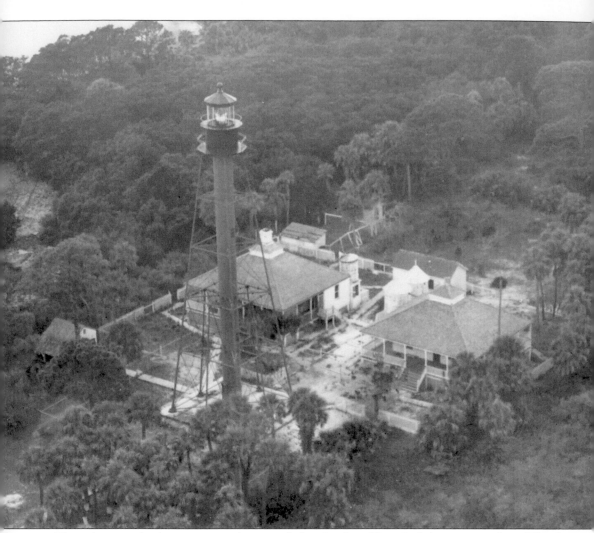

This photograph shows an aerial view of the Anclote Keys Lighthouse complex. (Florida State Archives.)

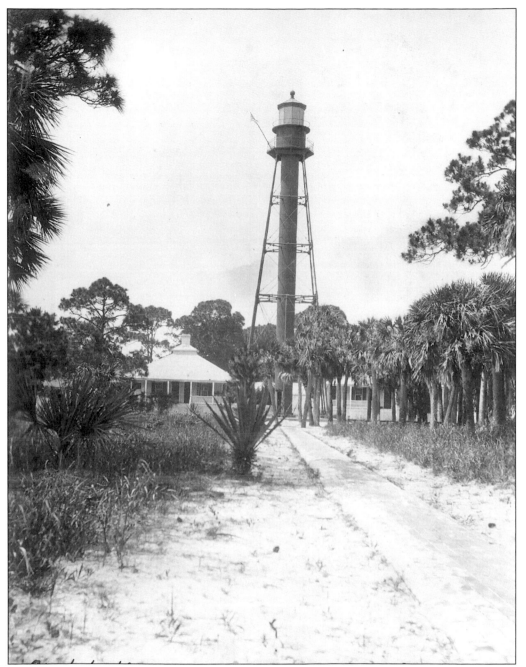

On April 17, 1913, this photograph of the Anclote Keys Lighthouse was taken. (U.S. Coast Guard Photo.)

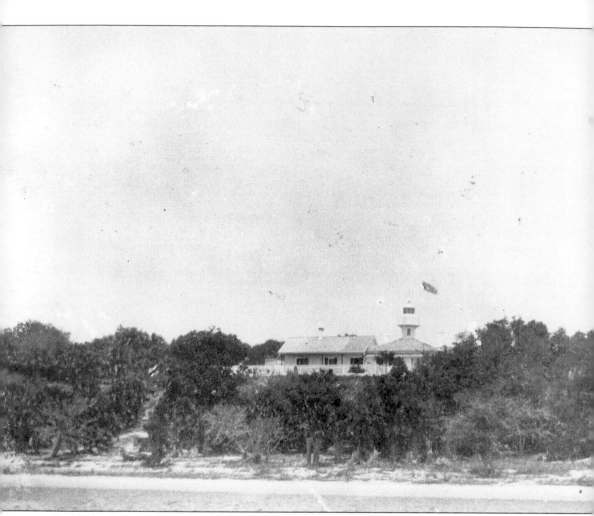

In 1854, a lighthouse was built upon a prominent hill on Seahorse Key in the Cedar Keys. The structure became known as the Cedar Keys Lighthouse. (National Archives.)

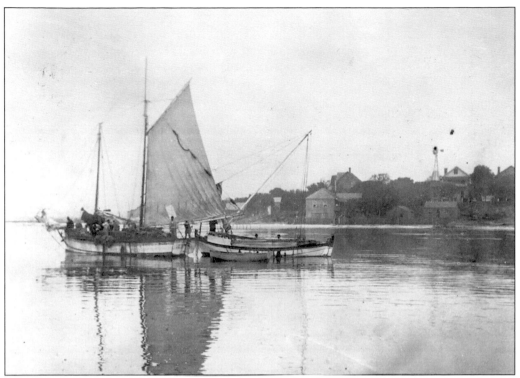

Many small vessels, such as this sponge schooner photographed in April, 1910, visited the waters off Cedar Keys. (Florida State Archives.)

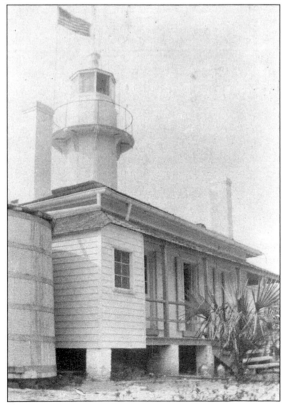

This close up view of the Cedar Keys Lighthouse was filed with an inspector's report in February of 1911. (National Archives.)

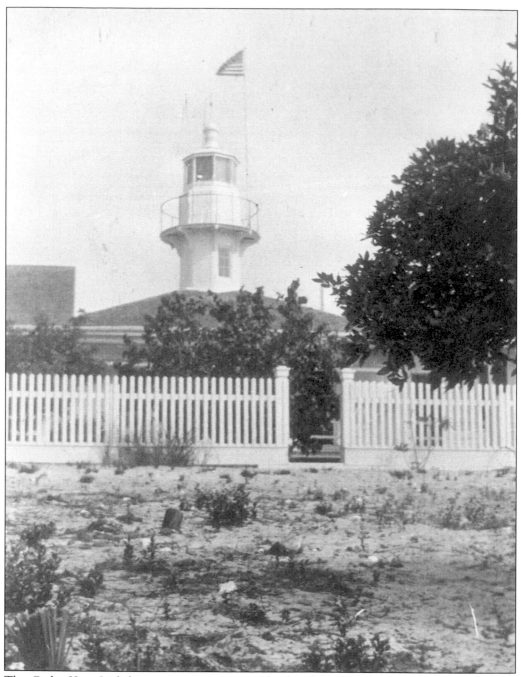

The Cedar Keys Lighthouse was an important landmark for vessels plying the waters of the northwestern Florida coast for over 60 years. The lighthouse ceased operation in 1915. It was then that it was taken over by the U.S. Department of Agriculture, when Seahorse Key became a part of the Cedar Island National Wildlife Refuge. In recent years, the structure has sheltered scientists and students from the University of Florida. (National Archives.)

Five

THE FLORIDA
PANHANDLE

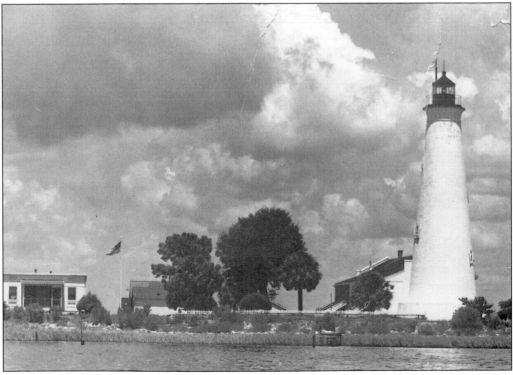

The St. Marks Lighthouse was photographed *c.* 1950. In 1960, the lighthouse was automated by the U.S. Coast Guard. (Florida State Archives.)

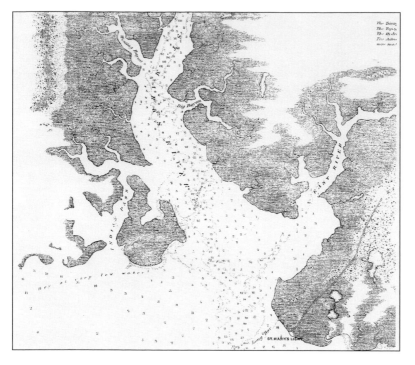

A nautical chart from 1860 shows the location of the St. Marks Lighthouse overlooking the St. Marks River.

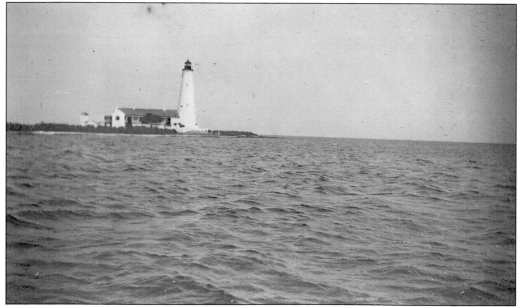

The St. Marks Lighthouse is shown as it appeared in 1914. (Florida State Archives.)

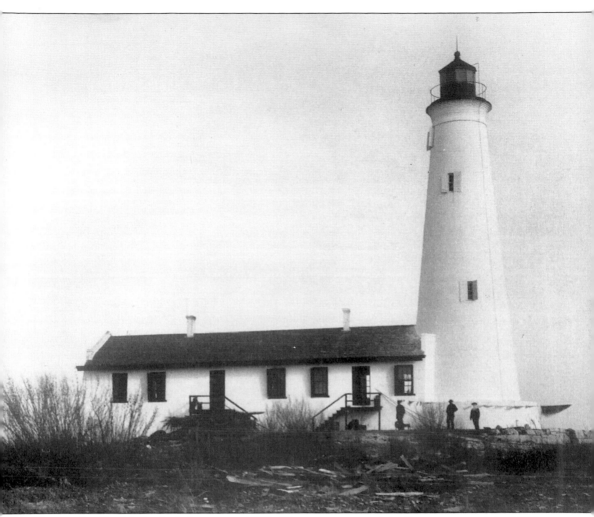

This is the St. Marks Lighthouse, *c.* 1885. The tower was originally constructed in 1842. According to historian David Cipra, this is the oldest lighthouse still in use on the Gulf of Mexico. (National Archives.)

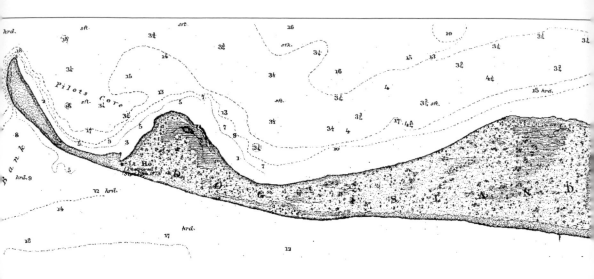

A portion of the nautical chart, Eastern Part of St. George's Sound, drawn in 1859, shows the location of Dog Island and the lighthouse. The first Dog Island Lighthouse was a 50-foot-tall tower completed in 1839. This structure was destroyed by a hurricane on October 5, 1842. The second lighthouse on Dog Island was a wooden structure standing 40 feet tall and was completed in 1843. It was destroyed by a hurricane in August of 1851.

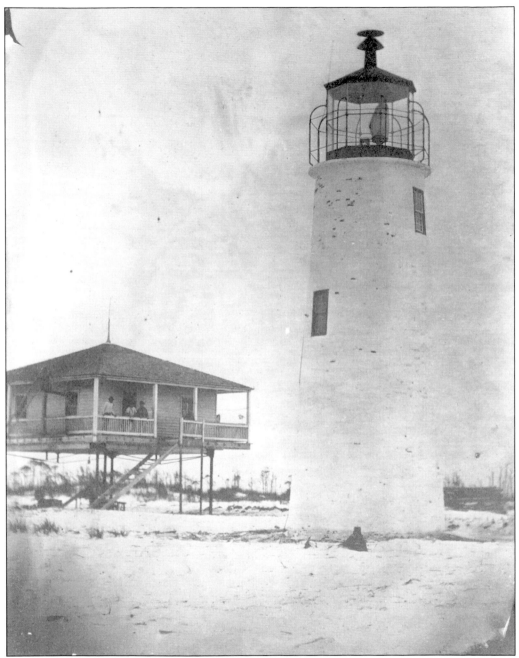

This photograph, taken in 1859, shows the final lighthouse to be constructed on Dog Island. Completed in 1852, the brick structure survived the Civil War, though it was severely damaged by fires lit by Union soldiers. Like its predecessors, the lighthouse was destroyed by a hurricane, which occurred on September 19, 1873. (U.S. Coast Guard photo.)

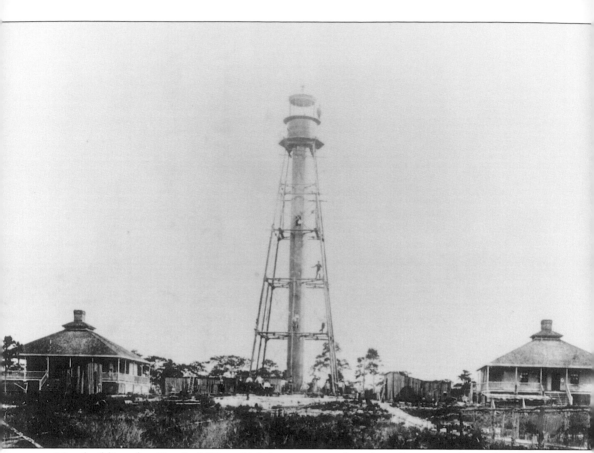

Men building the Crooked River Lighthouse stopped working long enough to show off their project as it neared completion in August 1895. (U.S. Coast Guard Photo.)

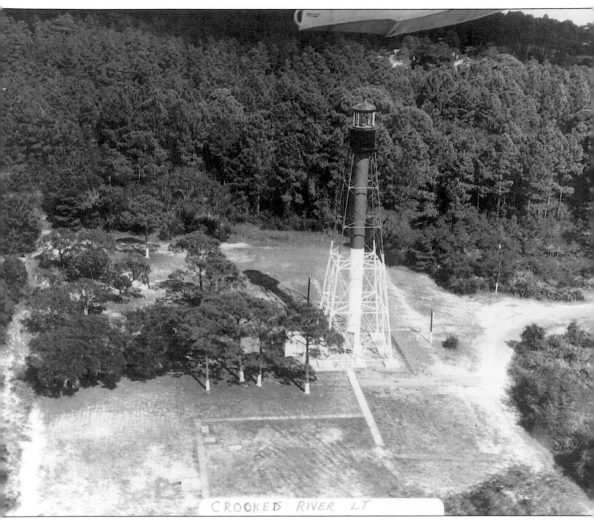

CROOKED RIVER LT

The iron skeleton Crooked River Lighthouse stands 103 feet high. In 1902, the structure was painted red on top and white on bottom. This was done in an effort to make it stand out against the dark forests in the background during daylight hours. (U.S. Coast Guard photo.)

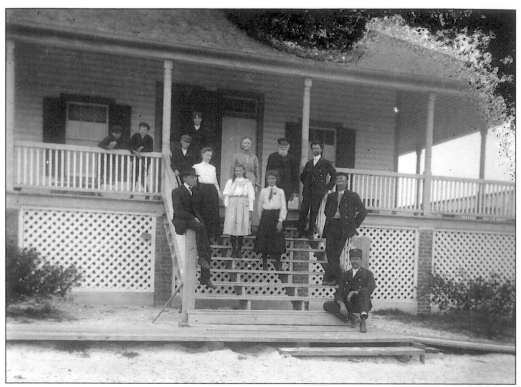

These individuals are gathered on the front porch of the lightkeeper's dwelling at Crooked River Lighthouse, c. 1910. (Florida State Archives.)

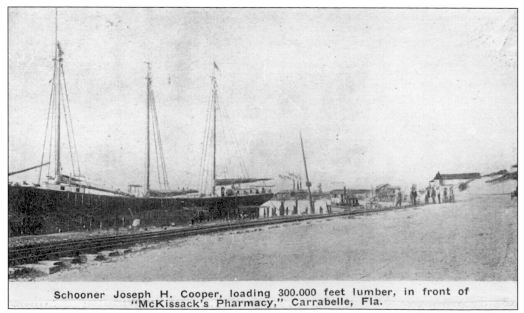

Schooner Joseph H. Cooper, loading 300.000 feet lumber, in front of "McKissack's Pharmacy," Carrabelle, Fla.

The Crooked River Lighthouse guided mariners into the busy port at Carrabelle, shown here on an old postcard. (Florida State Archives.)

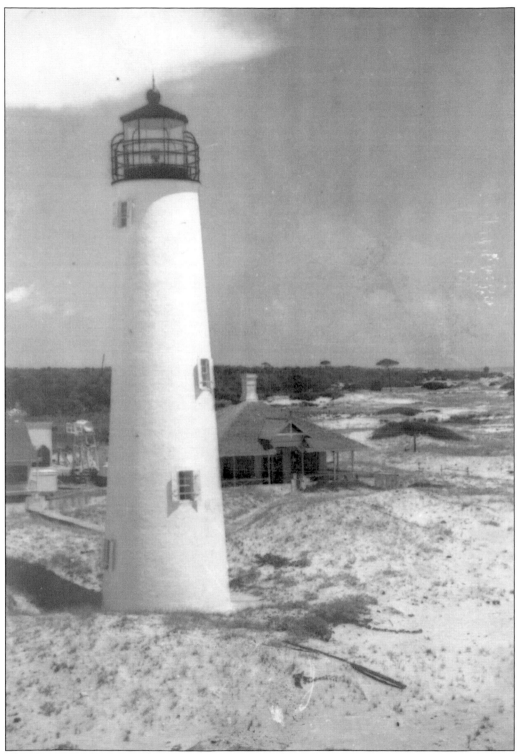

The Cape St. George Lighthouse was constructed in 1852. It is currently the second-oldest lighthouse on the Gulf Coast of Florida. (Florida State Archives.)

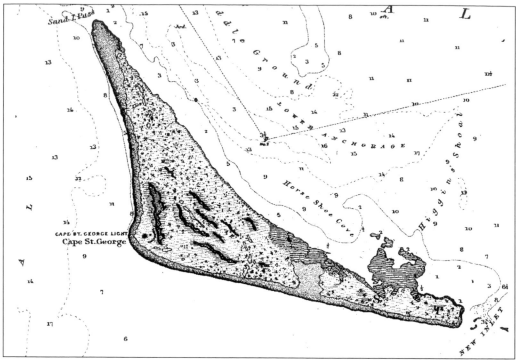

This section from a nautical chart drawn in 1860 shows the location of the Cape St. George Lighthouse. Two other lighthouses preceded the current structure on St. George Island. The first, built on the western end of the island in 1833, was deemed inadequate. So in 1848, a replacement was constructed at the point of the cape. The second structure was destroyed by a hurricane in August of 1851. This storm also destroyed the lighthouse at Cape San Blas and Dog Island.

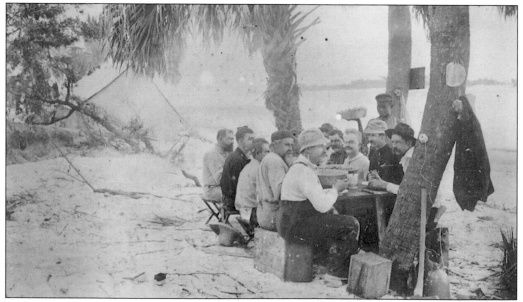

St. George Island has been a popular spot for outings. These individuals are enjoying a picnic on the island near the lighthouse, c. 1900. (Florida State Archives.)

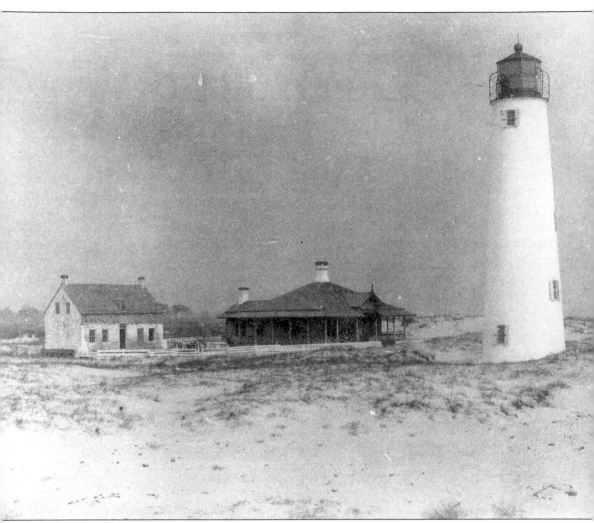

This photograph of the Cape St. George Lighthouse was taken *c*. 1905. (National Archives.)

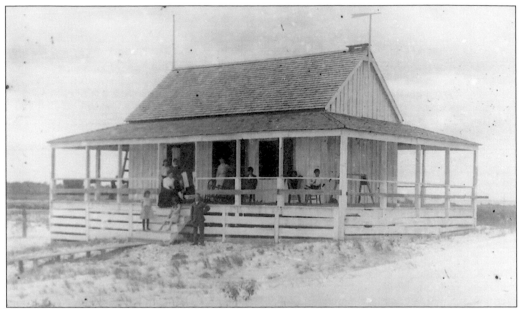

A group of people is gathered at the home of lightkeeper Edward Porter, c. 1910. (Florida State Archives.)

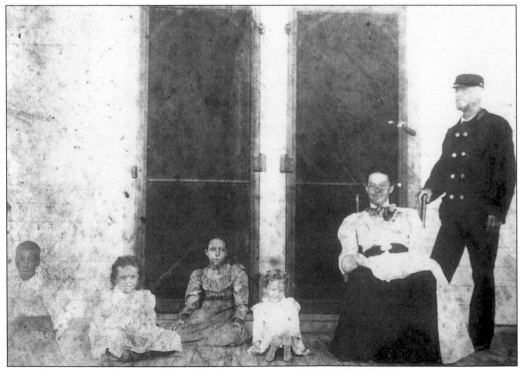

Edward G. Porter, keeper of the Cape St. George Lighthouse, is shown with his family on the front porch of the lightkeeper's home in 1900. Pictured here are, from left to right, as follows: Barnard, Josephine, Ethel, Eleanor, Jo with Pearl, and Edward Porter. (Florida State Archives.)

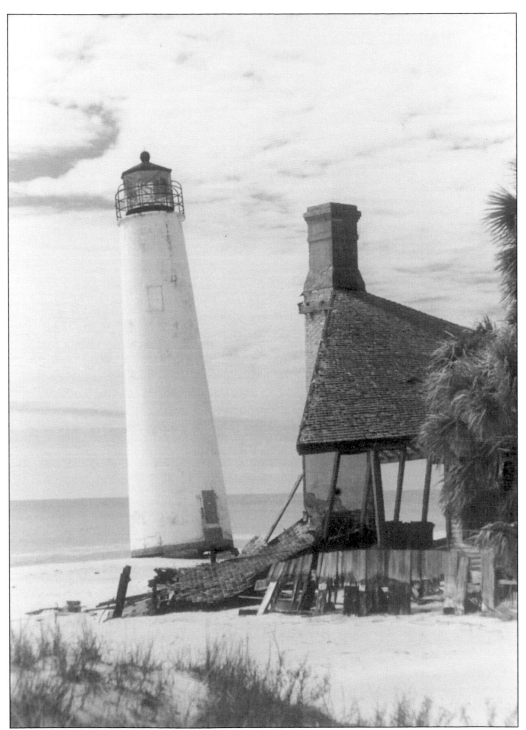

Erosion of the beach along Cape St. George nearly toppled the lighthouse into the sea. Some referred to the lighthouse as, "The Leaning Tower of Florida." Conservation efforts were mounted, however, and repairs were made in the spring of 1999. (Photo by Arnold Shore, courtesy of Bernice Shore.)

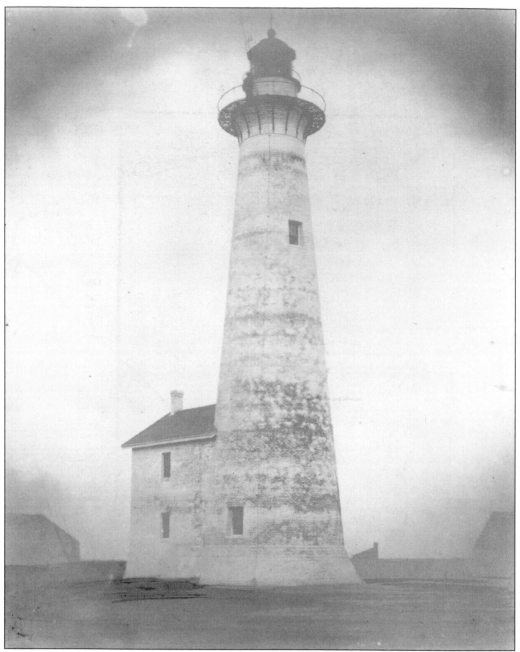

The Cape San Blas Lighthouses have been plagued with bad luck. The first structure, completed in 1848, was destroyed by a hurricane in August of 1851. The second lighthouse, completed in November of 1855, was also destroyed by a hurricane. The third structure (shown above), completed in 1859, lasted until it fell into the sea in 1882, a victim of erosion.

In 1884, the ship carrying the prefabricated iron towers for Cape San Blas and Sanibel Island wrecked off Sanibel. Both towers were salvaged, and the Cape San Blas Lighthouse was completed in February 1885. (U.S. Coast Guard photo.)

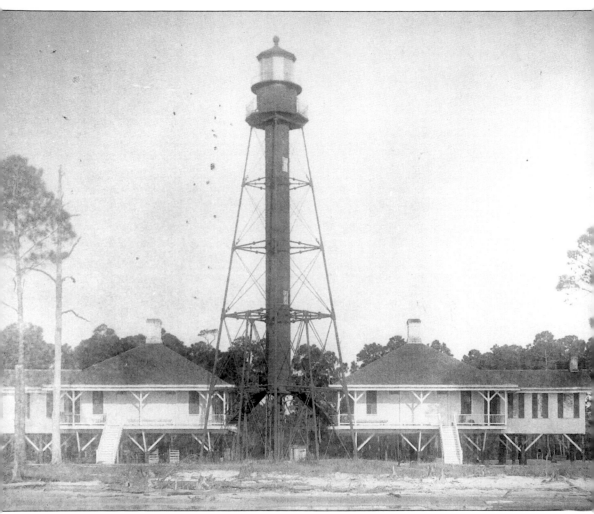

The Cape San Blas Lighthouse, completed in February 1885, was built 1,500 feet from the shores of the Gulf of Mexico. Within ten years, the sea had eroded the beach to the point where the Cape San Blas Lighthouse was standing in the water. In 1918, the tower was disassembled and moved to a site 640 yards inland. (U.S. Coast Guard photo.)

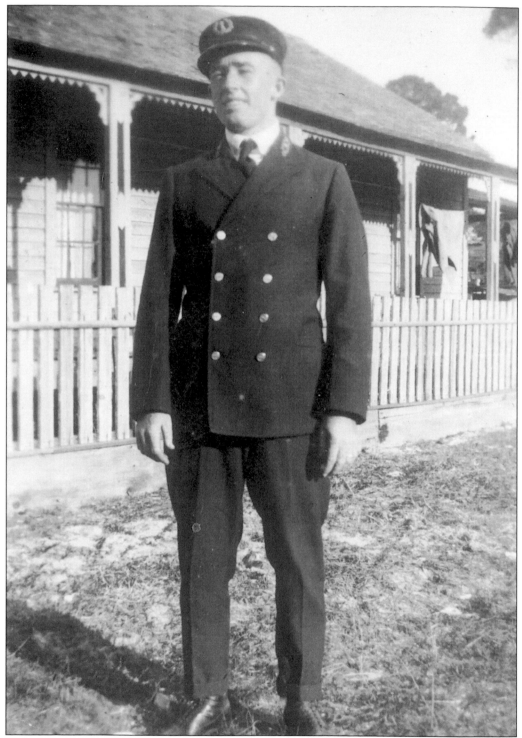

Walter A. Roberts served was lightkeeper at several locales along the Florida coast, including
Cape San Blas, Crooked River, and Cape Saint George. He is shown here *c.* 1920. (Florida
State Archives.)

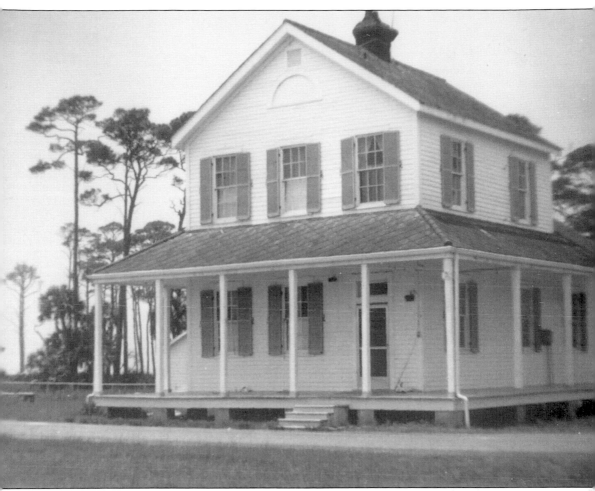

Shown here are the lightkeeper's quarters at Cape San Blas. (Florida State Archives.)

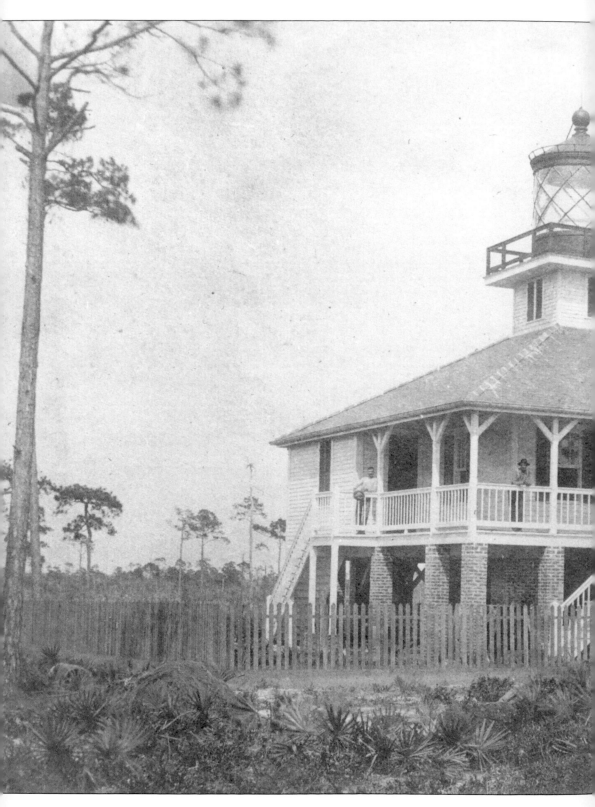

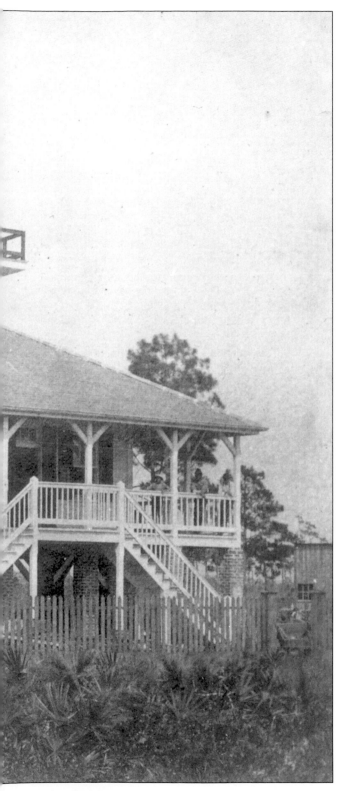

This is St. Joseph Point Lighthouse as it appeared on July 14, 1902, shortly after its construction. The light marked the entrance into St. Joseph Bay, until it was replaced by an unmanned steel tower in 1960. (National Archives.)

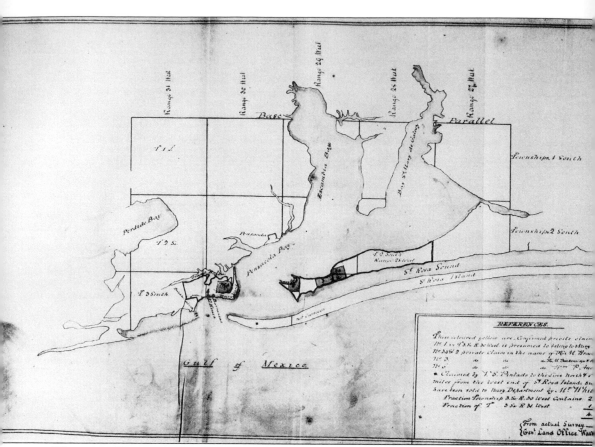

This map of Pensacola Bay, drawn in 1829, shows the location of the first Pensacola Lighthouse. (Territorial Papers of the United States.)

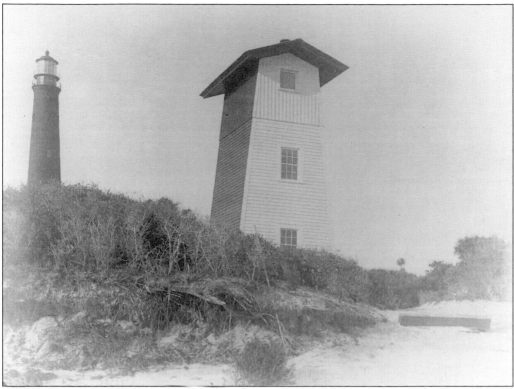

Pensacola Bar Beacon in the Pensacola Lighthouse is seen rising in the background. (U.S. Coast Guard photo.)

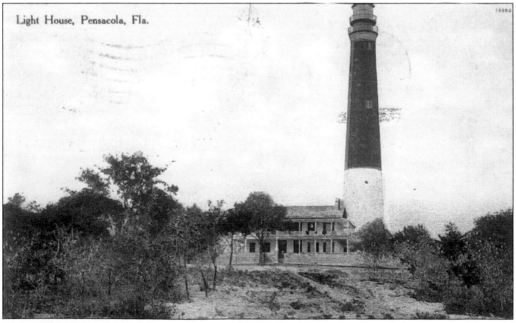

Light House, Pensacola, Fla.

This old postcard was postmarked in 1909. It shows the Pensacola Lighthouse and Keeper's Quarters.

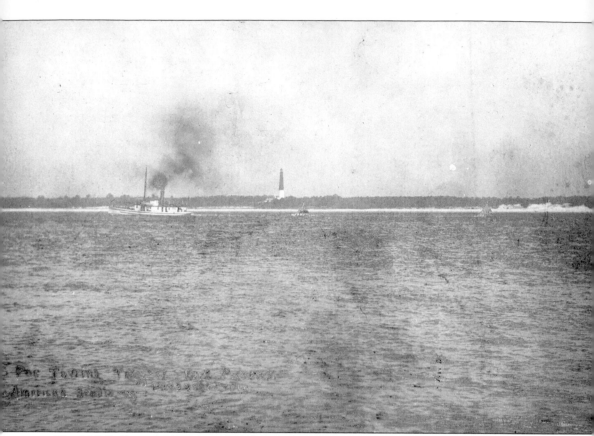

The U.S.S. *Poe*, which saw service during the Spanish-American War in 1898, is shown here on Pensacola Bay, c. 1910. The *Poe* was towing targets for gunnery practice. Note the Pensacola Lighthouse in the background. (Florida State Archives.)

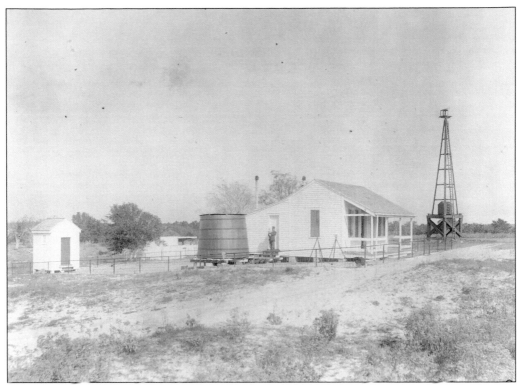

This is the Fort Barrancas Rear Range Light in 1892. (U.S. Coast Guard.)

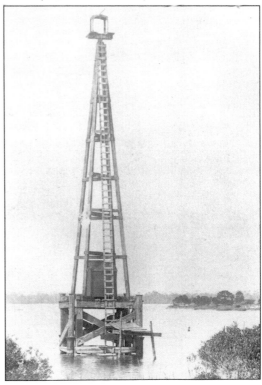

Here is the Fort McRae Rear Range Light in December 1892. (U.S. Coast Guard.)

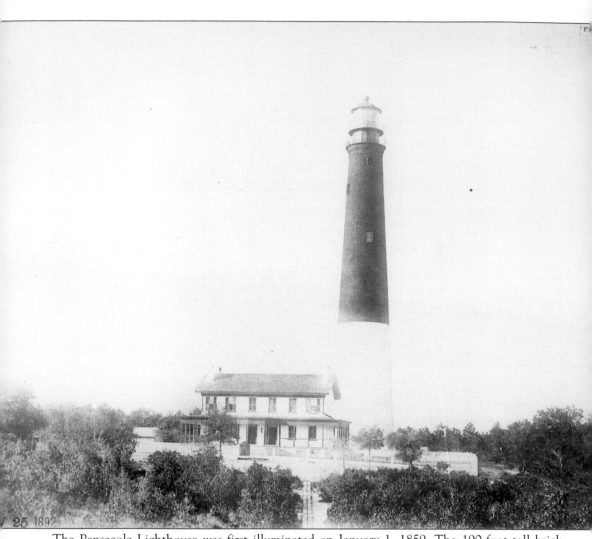

The Pensacola Lighthouse was first illuminated on January 1, 1859. The 190-foot-tall brick structure replaced an earlier lighthouse that had been in operation nearby since 1826. The light from the old tower was considered inadequate and was often unable to be seen, as the building was only 30 feet tall. Thus, the new, taller tower was erected.

The lighthouse at Pensacola has seen many trials and tribulations. During the Civil War, the lighthouse was struck by Union canon fire during the battle for Fort Pickens. Later, in 1875, the building was twice struck by lightning. On August 31, 1886, the structure was shaken by the powerful Charleston Earthquake, creating what was described as, "a rumbling, as if people were ascending the steps, making as much noise as possible." (National Archives.)

LIGHTHOUSE INDEX

Discover Thousands of Local History Books
Featuring Millions of Vintage Images

Arcadia Publishing, the leading local history publisher in the United States, is committed to making history accessible and meaningful through publishing books that celebrate and preserve the heritage of America's people and places.

Find more books like this at
www.arcadiapublishing.com

Search for your hometown history, your old stomping grounds, and even your favorite sports team.